THE
Archive Photographs
SERIES

ROATH, SPLOTT
AND ADAMSDOWN

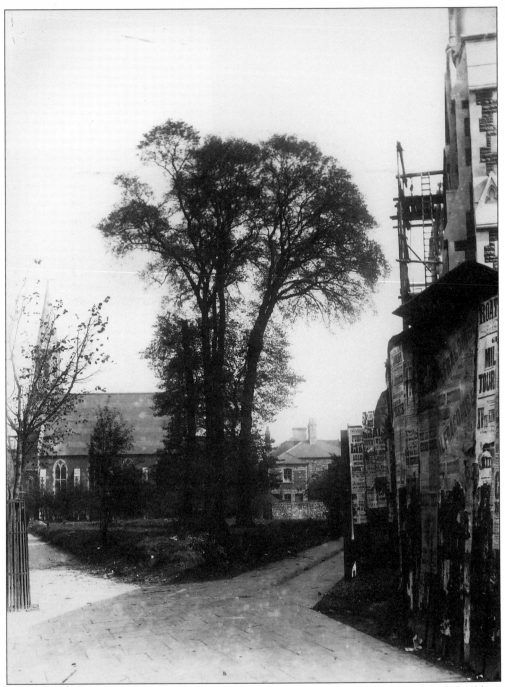

The original four elms at the junction of Newport Road and Broadway, 1897. The building under construction on the right is the Trinity Methodist Church which opened in 1897. The triangular site today accommodates the Roath Branch Library (opened 1901) and its garden. The name is perpetuated in Four Elms Road and, until recently, by the Four Elms Hotel.

THE
Archive Photographs
SERIES

ROATH, SPLOTT
AND ADAMSDOWN

Compiled by
Jeff Childs
on behalf of Roath Local History Society

CHALFORD

First published 1995
Copyright © Jeff Childs, 1995

The Chalford Publishing Company
St Mary's Mill, Chalford,
Stroud, Gloucestershire, GL6 8NX

ISBN 0 7524 0199 8

Typesetting and origination by
The Chalford Publishing Company
Printed in Great Britain by
Redwood Books, Trowbridge

This book is dedicated to the memory of Alec Keir,
founder of the Roath Local History Society and a great inspiration.

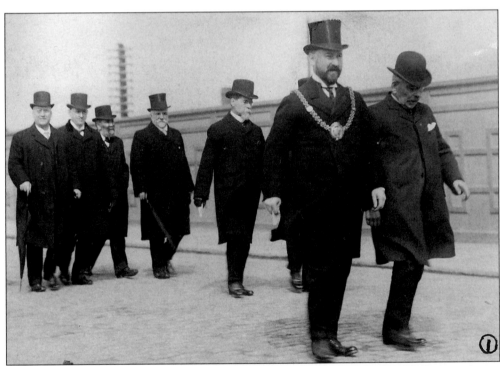

The Lord Mayor, Councillor Illtyd Thomas J.P. invites members of the Cardiff Corporation to walk with him over the new Beresford Bridge after the official opening on 30 March 1908. Some of those present were Cllr. John Mander (Chairman of the Public Works Committee); Cllr. W.H.D. Caple (Deputy Chairman); M. Harpur (City Engineer) and J.L. Wheatley (Town Clerk). The bridge was erected by the G.W.R. Company over whose line it ran.

Contents

Foreword 7

Introduction 8

1. Parish 11

2. Village 19

3. Farms 27

4. Houses 37

5. Churches and Chapels 49

6. Education and Health 71

7. Streets 87

8. Shops 117

9. Trade, Industry and Transport 129

10. Leisure and Recreation 147

Acknowledgements 160

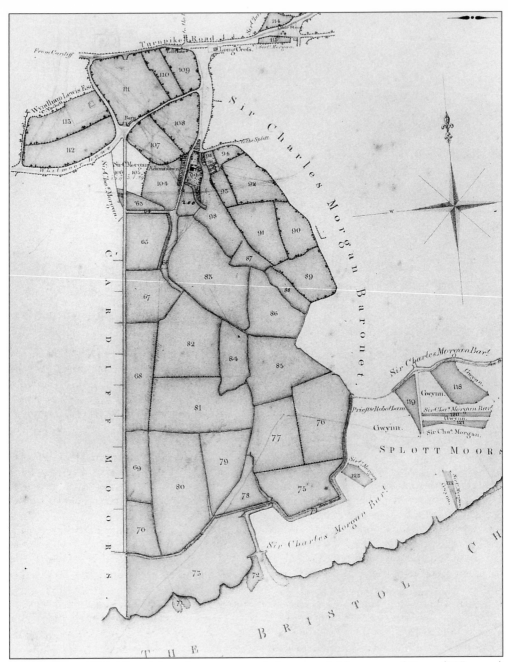

Adamsdown, 1824. The Adamsdown estate of the second Marquess of Bute (397 acres) straddled three parishes: Roath, Cardiff St John's and Cardiff St Mary's, though the greatest portion (275 acres) lay in Roath. Plot 97 is Adamsdown farmhouse and plot 99 is Adamsdown House, tenanted by John Bradley and Whitlock Nicholl repectively. Both properties were demolished in the mid-1870s, by which time the estate had been bisected by the South Wales Railway (later the Great Western Railway) and much of the land had been taken up by industrial undertakings – a proliferation of wagon, brick, gas, chemical and copper works. 1891 saw the most momentous change of all when the Dowlais Iron Company started production.

6

Foreword

By Mrs Susan Williams M.B.E., J.P., former Lord Lieutenant of South Glamorgan

As the great-granddaughter of Charles Crofts Williams I was delighted to be asked to write the foreword to this book. Charles Crofts Williams was an eminent citizen of Cardiff and the county of Glamorgan who achieved several renowned positions in political and social affairs. When he died in 1860 I understand that the muffled bells of St John's Church, Cardiff were tolled for 12 hours to mourn him. In a very minor way I have tried to follow his great example of citizenship in that I have been a magistrate, High Sheriff of the old county of Glamorgan and Lord Lieutenant of South Glamorgan.

After his death, his son Charles Henry Williams lived at Roath Court. He married Millicent Frances Herring – a descendant of an Archbishop of Canterbury – and they had seven surviving children, of whom Robert Henry Williams, the second son, was my father. Charles Henry Williams kept a pack of harriers at Roath Court and my father told me that one of their most popular meets was in fields where the Park Hotel now stands.

My earliest memory of Roath Court was being taken there by my parents to visit my grandmother, Charles Henry Williams's widow. She seemed a very old lady and rather frightening, but always had chocolate to give us. She died in 1928 in her eighties. Roath Court was then occupied by my uncle Claude and aunt Rosie, bachelor and spinster, until they died in 1952.

The family was for many years cared for by Miss Edith Timbers. She came there as a girl in the early twenties and devoted her whole life to the Williams family. She retired when Rose, the last of them, died. In recognition of her wonderful service Timbers Square (developed from 1955), adjoining Roath Court, was named after her.

So ended the connection of the Williams family with Roath Court. As a very dignified funeral home I feel it fulfils a great need in the City of Cardiff.

Susan Williams

27. 6. 95.

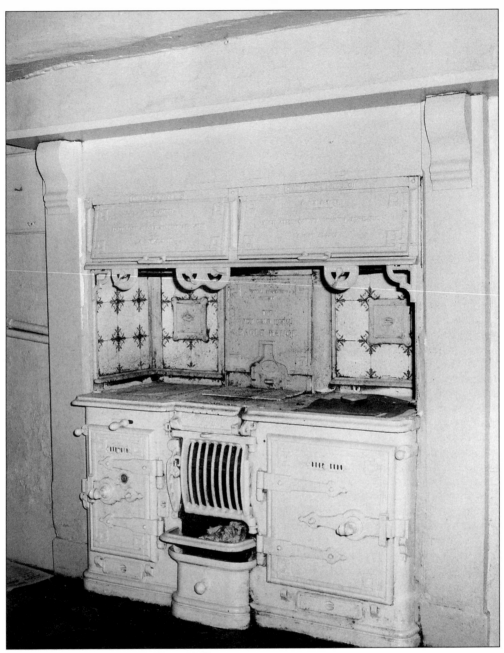

Cooking range, Ty Mawr, January 1967.

Introduction

The modern electoral districts of Roath, Splott and Adamsdown betray an 'ancient' significance, one which this photographic study will seek in part to capture. Its focus is the ecclesiastical parish of Roath created in the late sixteenth century, although Roath as an entity is much older. Reputed to be pre-Norman in origin, in its time it has served as a manor, parish and village, as well as a latter-day suburb. In terms of written documentation Roath first emerges in the medieval period when it was established as the principal manor of the Normans in these parts. Originally there was one manor but during the twelfth century it became fragmented and as a result of territorial appropriations by monastic houses three manors came to exist: Roath Tewkesbury; Roath Keynsham and what remained of the original manor (called Roath Dogfield from the sixteenth century). These manors fell within the commote of Cibwr, originally a pre-Norman district of some 13,000 acres but which became co-terminous with the Norman lordship of Cardiff.

Roath Dogfield covered some 4,000 acres, though like Roath Keynsham, also some 4,000 acres in size, it was territorially dispersed. Its core was the town of Cardiff and, in modern day parlance, Adamsdown – part of Splott and Tremorfa. It also covered that part of St Mary's parish that is today Butetown, as well as sections of Llanishen and Lisvane. The area which Roath Tewkesbury comprised is unclear but the core of Roath Keynsham was Penylan, Cyncoed and Llwynygrant though there were significant outliers at Pengam and Llanishen, notably the area covered today by the Thornhill private housing estate and crematorium. It also extended into Whitchurch parish.

Splott was separate from the Roath manors, it being an 'independent' episcopal estate of the bishop of Llandaff. Splott is an English word, a synonym of 'splat', a piece or patch of ground. A frequent example of the dialect of South West England and across Oxfordshire and Hampshire was the placing of 's' at the beginning of words. It came to these parts in the speech of West Country immigrants over the centuries and is not unique to Cardiff as it appears both as field names and farms in the Vale of Glamorgan, Gower and Pembrokeshire.

A rich array of manorial records survive, notably ministers' accounts, inquisitions post mortem and surveys. From their study over time one can see the development of placenames. This is particularly the case from the late fourteenth century, a period which witnessed the progressive farming-out of manorial land. Some placenames survive today e.g. Adamsdowne, Estmore, Portmannesmore and Splott but others such as Adamscrofte, Gyldenhokes, Holmead Parva, Nebbercroft, Margerislonde, Rothmonleys, Skottescroft, Waterlederyscrofte and Yelonde have long disappeared.

There is no physical reminder of the manor in the area today. The present Roath Court, although occupying a pre-Norman site – the 'rath' (a circular mound surrounded by a ditch) from which the name is said to derive – dates from the eighteenth century whilst the successor to the Norman mill was demolished in 1897. Enough survives, however, from more recent times to make a work such as this entirely appropriate.

This book has been compiled on behalf of the Roath Local History Society. The Society was formed in November 1978 and takes as its unit of study the ecclesiastical parish of Roath. It meets every second Thursday of the month at the Mackintosh Residents' Community Centre, Keppoch Street, and has a varied programme of lectures, field trips and project work. Its members are also available to give illustrated talks on the old parish.

Corfield & Morgan's outing to Llantwit Major, 1894. The man seated in the centre is W.H. Booth, an indefatigable local photographer who lived at 13 Wellfield Road. Many of his photographs are included in this compilation. He had a particularly acute eye for street life and social conditions. Historians of Cardiff owe William Booth a great debt.

One

Parish

The parish of Roath was some 3,500 acres (if the area covered by water or the sea coast is included; otherwise one can accept the usually reliable tithe apportionment figure of 2,430 acres). Geographically, it stretched from the town of Cardiff in the west, the boundary running from the present junction of Crwys Road with Fairoak Road southwards along Crwys Road and City Road to its junction with Newport Road (i.e. the parish shared on its western side the same boundary as that delineating the eastern extremity of the medieval borough of Cardiff). The parish's eastern demarcation was the river Rhymney which also served as the county boundary between Glamorganshire and Monmouthshire. In the west the parish was bounded by the parishes of Cardiff St Mary's and Cardiff St John's, to the north by the parish of Llanishen, to the north-east by the parish of Llanedeyrn and to the east by the parish of Rumney. The Severn estuary formed a natural boundary to the south. Roath became incorporated into the borough of Cardiff in 1875. (Note: the area covered by the Roath Park Botanical Gardens and Lake, an erstwhile area of rough pasture, historically formed part of Llanishen parish and consequently is not featured in this work.)

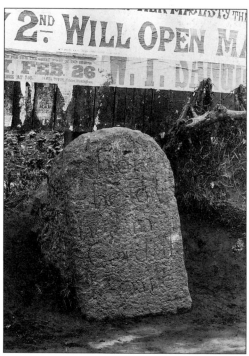

This ancient milestone is preserved *in situ* in the triangular garden of Roath Branch Library, Newport Road. Photographed in 1891, the inscription seems to read "From the Town Hall in Cardiff 1 mile". This would be the High Street Town Hall, the second in Cardiff's history, which was demolished in 1861. The stone probably dates from the 1760s when the turnpike trusts were established, and it appears on George Yates's 1799 map of Glamorgan.

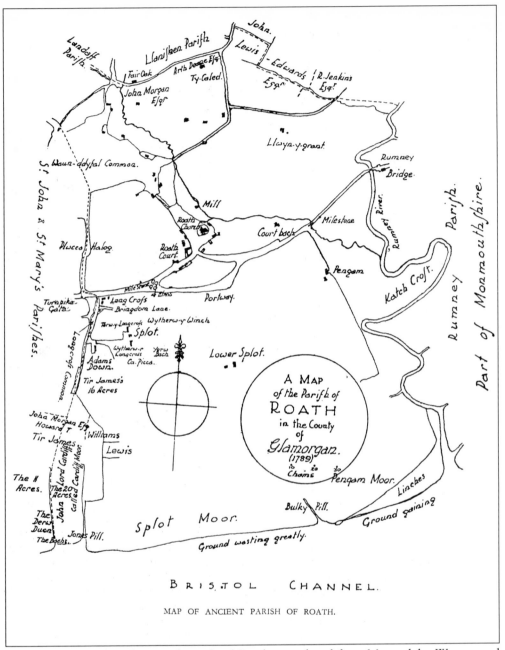

A 1789 map of the ecclesiastical parish of Roath reproduced from Marmaduke Warner and
A.C. Hooper (eds.) *The History of Roath St. German's* (Cardiff 1934).

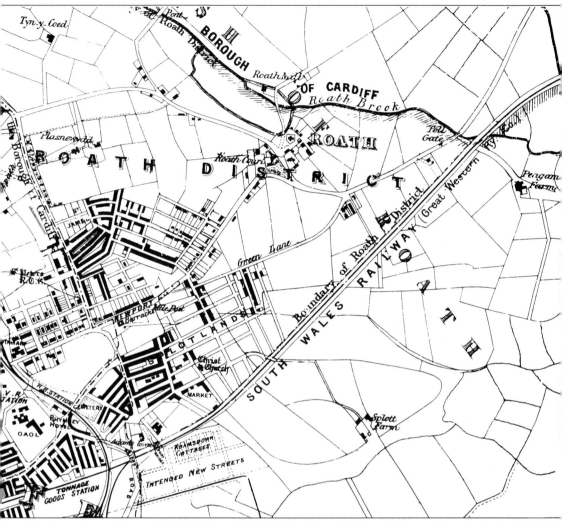

The map *opposite* shows the parish very much as it would have been when it was so designated in the late sixteenth century. The nucleus of the parish was its village grouped around St Margaret's Church and Roath Court. The principal farmsteads were Splott (Upper and Lower), Adamsdown (now the site in part of Adamsdown Gospel Hall) and Pengam. The milestone shown on the previous page is marked near the '4 Elms'. The contrast with the map *above* in terms of urban development is evident. This is an extract from T. Waring's *District Plan of Cardiff & Penarth Including Roath, Canton & Llandaff May 1869.* Note the South Wales Railway completed in 1850; the Longcross army barracks (Newport Road) built *c.* 1850; Christ Church (or the Splott Chapel) in Metal Street, built in 1857 and formerly the barn of Upper Splott Farm; Roath Market (Constellation Street) established 1862, and the (proposed) Adamsdown Cottages between (today) Cumnock Place and Sanquahar Street owned by the Cardiff Workmens Cottage Company, established in 1869. The "intended new streets" to the immediate south were never built, the Marquess of Bute's agents, on whose land they would have lain, evidently considering it more remunerative to lease the land for the use of the saw mills and timber yards which existed there up to recent times.

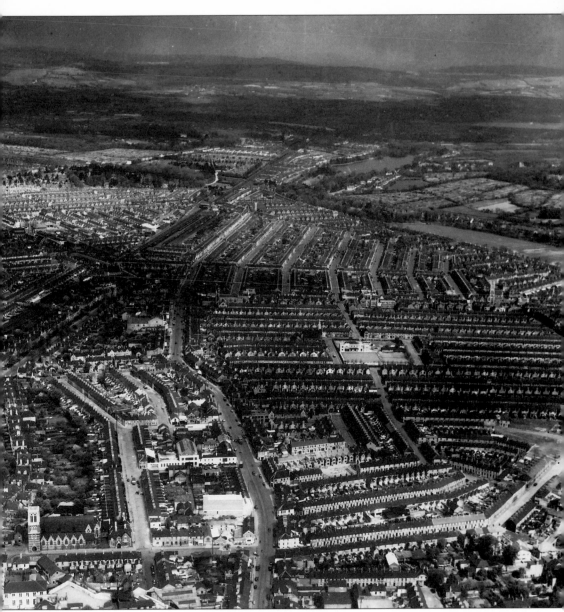

Aerial view of what was the north-east portion of the parish taken on 29 April 1948 and showing today's Plasnewydd district. In the centre is the Mackintosh Institute (formerly Plasnewydd). The Roath portion of the Mackintosh estate covered 124 acres and was bounded on the west by City Road (the parish boundary), on the east by Cottrell Road, to the north by Penywain Road and to the south by Cyfarthfa Street. The former ecclesiastical parishes of Llanishen, Lisvane and Llanedeyrn lie to the north; in the medieval period much of the latter areas were in the Welsh district of Cibwr.

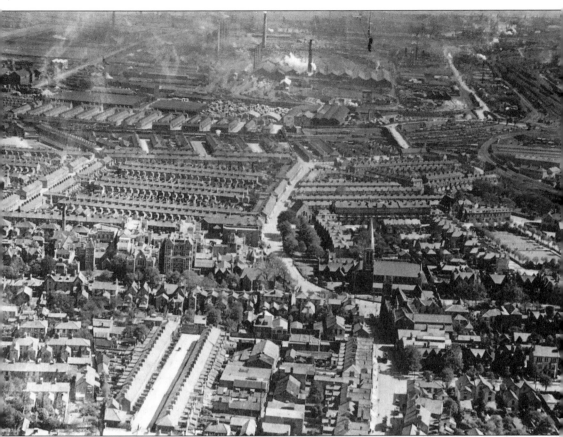

Looking south to Adamsdown, 1923. The parish boundary follows the line of City Road, Glossop Road and Meteor Street. Prominent features include Roath Road Wesleyan Methodist Church, St James's Church, the Cardiff Royal Infirmary, the 'Adamsdown Cottages' and the G.K.N. Steelworks (East Moors). In the top left is the Maltings (built in 1887) at the start of Lewis Road leading to the Tharsis Sulphur and Copper Works (just visible). Portmanmoor Road is top far left and to the centre right is the Howard Gardens School which, like Roath Road Wesleyan Methodist Church, was severely damaged in the blitz. Adamsdown was traditionally a perquisite of the gatekeeper or porter of Cardiff Castle. The name is possibly derived from one Adam Kyngot, gatekeeper, who is mentioned in an inquisition post mortem of 1440.

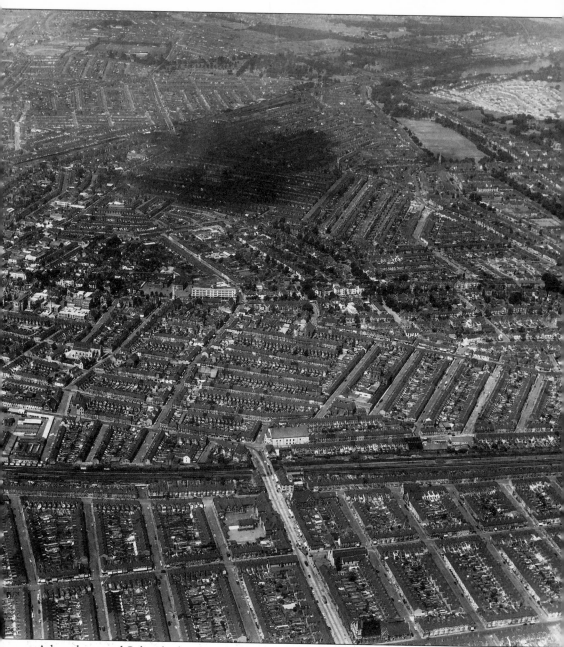

Adamsdown and Splott looking north, 1961. Splott Road clearly stands out. Also to be seen are Splott Road Wesleyan Methodist Church, St Saviour's Church, Splott Road Baptist Church, Splotlands Board School and Splott cinema. Behind the cinema lies the Diamond Street Methodist Church and S.A. Brain's New Brewery (established *c.* 1930) and Bottling Stores (established 1904) – both demolished in 1995. Roath market and slaughterhouse is to the left, above the railway, and just north of it is St German's church. The white building, centre left, is Graham Buildings (built 1928-9 and demolished 1986-7). Behind it is Elm Street, one of Roath's oldest streets. Top left is the district of Cathays most of which fell historically in the parish of Cardiff, St John's.

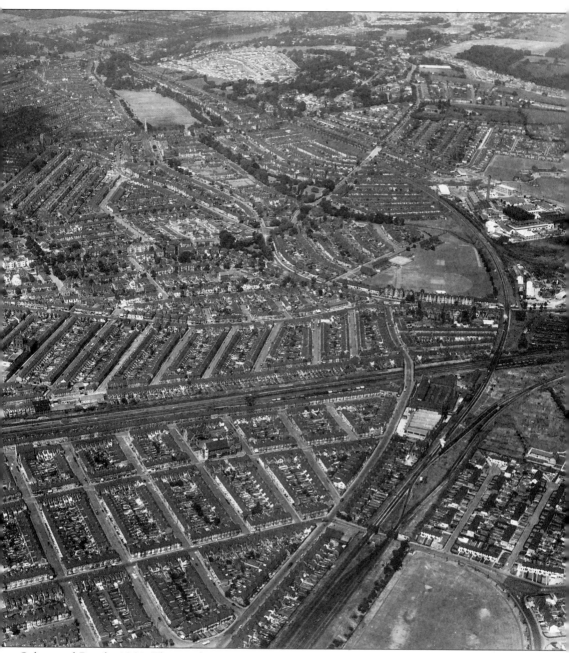

Splott and Roath, 1961. The northern portion of Splott Park is just in view. Also visible is St Alban's Church, the C.W.S. Biscuit Factory, Beresford Bridge, the South Wales Railway, the Roath branch line of the former Taff Vale Railway, the Harlequins' recreation ground, the Metal Alloy Works, Roath Park recreation ground and Roath Park lake.

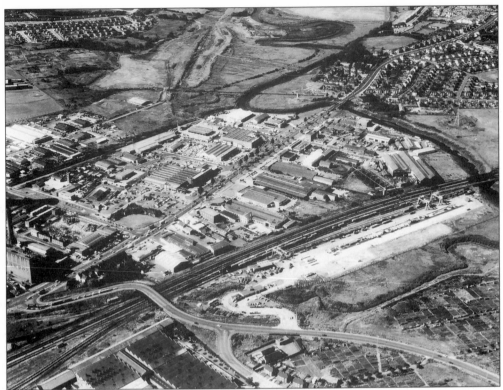

The easternmost part of the parish showing the Newport Road industrial estate and the Rhymney river in 1969. The estate was developed c. 1957, but has undergone dramatic change since the late 1980s with the onset of edge-of-town retail outlets here. In the bottom left is the Rover Works, built in 1961 but closed in the early 1980s. Much of the land to the left of Newport Road was known in the medieval period as Griffithsmoor.

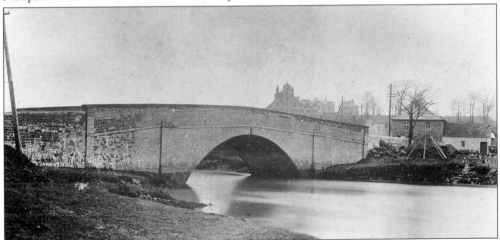

The parish boundary on the eastern side, c. 1880. The River Rhymney at one time was also the county boundary between Glamorgan and Monmouthshire. This is the predecessor of the current bridge which opened on 14 January 1912. On the eastern bank is Rumney Pottery, while Rumney House, the then home of William Cubitt, banker, can be seen in the background.

Two
Village

The village of Roath was medieval in origin. It emerged as a cluster of buildings close to the manor house or home farm (Roath Court) and church (St Margaret's). They served as farm buildings comprising barton, grange and wattled ox-houses. The 1841 census enumerators' return reveals that the village community comprised some 80 people but by 1900 it had begun to lose its identity as a result of suburbanisation.

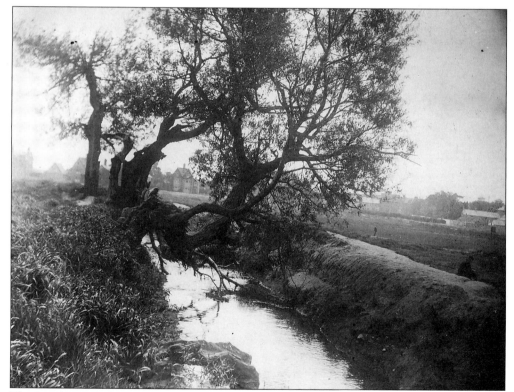

The Roath Brook (otherwise known as the Nant Fawr, Nant Llechau or Licky) in 1910. Roath Court is to the right and Church Terrace (developed from 1881) is in the background, the property to the far left being St Margaret's House of Mercy and Children's Home.

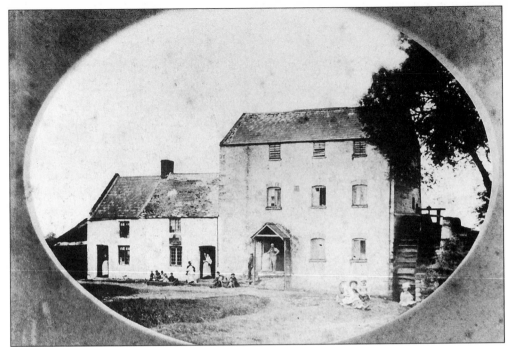

Two views of Roath Mill, an ancient water-grist establishment which stood on the Nant Llechau, a little north-west of Roath church. It served as the lord's mill in the manor of Roath Keynsham. This building dates from the eighteenth century, but it occupied the site of its medieval predecessor. It was demolished in 1897. The photograph *above* is said to date from 1877, in which case the man in the doorway may be James Rowe from St Martin's, Cornwall. He is recorded there on census night in 1871 along with his wife Sarah, two sons and one daughter. The picture *below* dates from c. 1890.

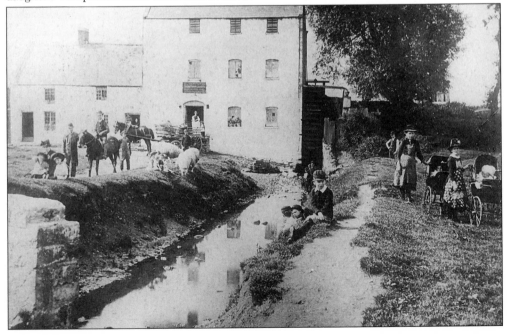

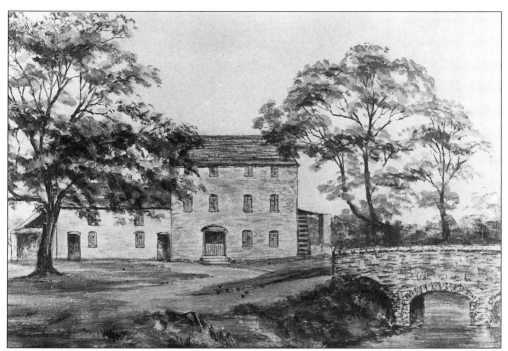

Two views of Roath Mill in 1886. The one *above* is from an original watercolour by William Bowen Hodkinson. The mill was on Tredegar Park estate land, Lord Tredegar being the Lord of the Manor of Roath Keynsham. Trade directories for 1891-5 name one George Burfitt as living there. He was the mill's last occupier. The name is preserved in Roath Mill Gardens presented by Lord Tredegar to the Cardiff Corporation in 1906 and opened on 23 October 1912.

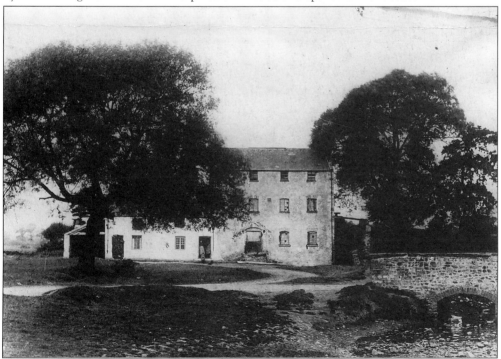

Albany Road, 1890, showing the 'white wall' running alongside the Roath Court demesne. At one time it ran up to where the Texaco garage now stands (next to the Claude Hotel), although the boundary of the Roath Court estate extended as far as Cottrell Road.

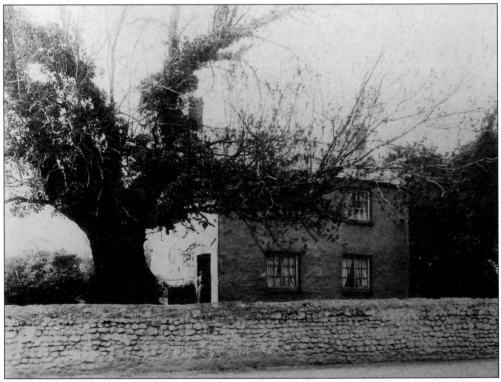

Roath village school, *c.* 1890. Miss Florence Parkes was the mistress there in 1892. When it ceased as a school about 1902 the building seems to have become known as Roath Court Cottage and was occupied for many years by John Young. The school is also shown on the 1840 tithe map. The photograph on page 71 shows the interior.

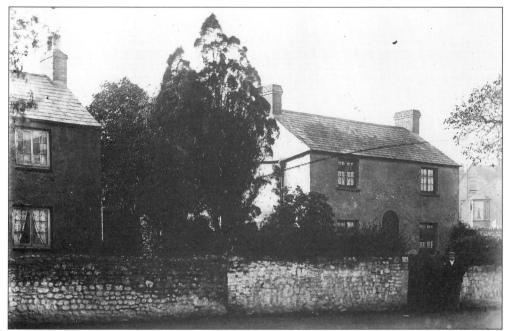

Walnut Tree Cottage in Albany Road, 1894, showing the school house on the left. The gentleman posing may be William Pigeon, a Devonshire signalman. He was the occupier in 1894-5. At the end of the First World War, John Scott, the butler at Roath Court, was resident there. The property is named as Spring Cottage on the first edition of the Ordnance Survey map (1879).

Albany Road, 1908, showing, behind the trees, Roath Court Cottage (formerly the school), Walnut Tree Cottage and three other cottages that formed part of the Roath Court estate and housed its employees (see next photograph).

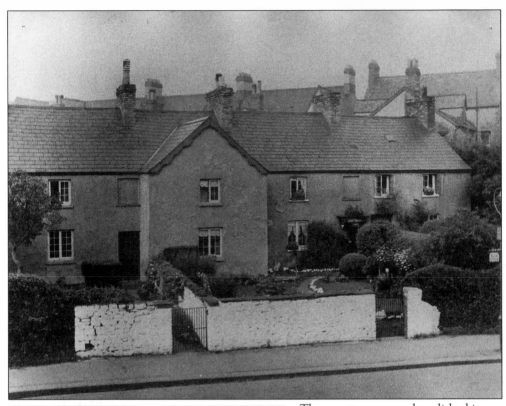

These cottages were demolished in 1959. They stood next to the Claude Hotel. In 1958 they were collectively known as Roath Court Cottages. Previously they were known, from left to right, as Jessamine Cottage 1, Jessamine Cottage 2 and White Rose Cottage. The latter was occupied in 1893-4 by James Raynor, coachman to the Roath Court estate.

Penylan Road close to its junction with Albany Road, 1892. The three cottages can be seen in the distance, as can the Claude Hotel which was built in 1890 and named after Claude, the third son of Charles Henry Williams of Roath Court, on whose land it lay. The white building on the immediate left is an outbuilding of Cross Cottage. The larger building is the Roath Park Refreshment Room.

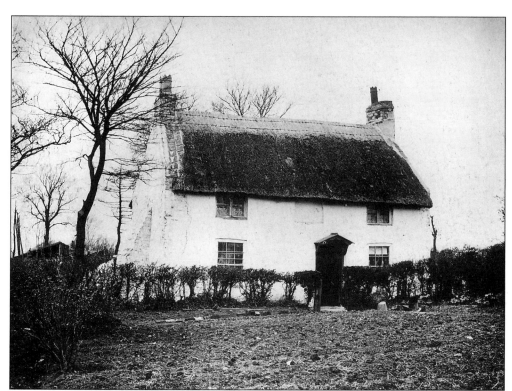

Cross Cottage, 1883. It lay at the corner of Penylan Road and Merthyr Road (Albany Road). It was demolished in 1899.

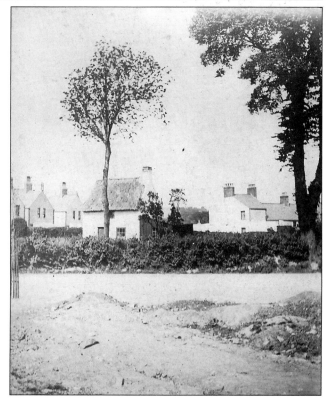

Pant yr Wyn, April 1893, just off Albany Road near to the junction with Claude Road. Pant yr Wyn was demolished when Wellfield Place was built in 1894 (see page 95). To the left is Wellfield Road, and to the right lies Tai Cochion (the Red Houses).

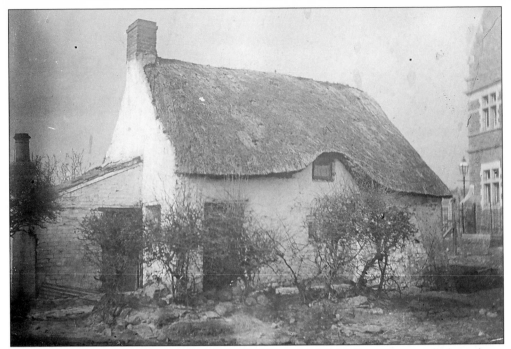

Ty-y-cwn the dogs' house so named as the lord of the manor's hounds were reputedly kept there. A small, but solidly built, cottage, it had a thatched roof and a mullioned window with stone frame, joist and hood moulding apparently dating from the sixteenth century. It was demolished in May 1898, the year when the Albany Road Baptist Church School, seen to the right, was opened.

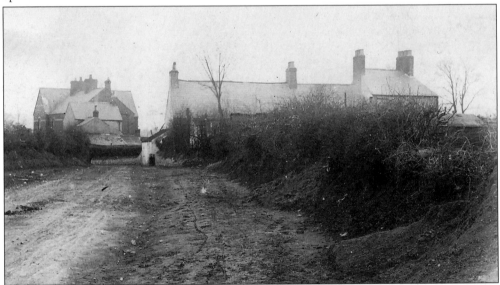

Tai Cochion, 1892. A rambling house divided into tenements, it was also known as Roath workhouse. It is said that the building derived its name from the red pantiles of the roof. Penylan Road is shown leading in the direction of Albany Road – the camera shot gives a false impression of it being uphill. The property to the left is part of the Delta Place cluster of cottages. The latter, like Tai Cochion, were demolished in 1899.

Three

Farms

Up until 1850, although the open strip fields associated with the manorial system had long disappeared, the parish was still predominantly agricultural. It comprised one or two genteel residences and about a dozen farms, several of which later gave their names to wider districts. The principal farms, with their acreages, were Splott (378), Pengam (351), Adamsdown (271), Lower Llwyn y Grant (160), Deans Farm (117), Ty Gwyn and Penylan (115), Ty Mawr (101), Penywain (91), (part of) Upper Llwyn y Grant (66), Ty yn y Coed (68) and Ty Draw (49). In addition, the Roath Court and Plasnewydd estates were 91 and 124 acres respectively. Farming was predominantly pastoral with two thirds of the parish given over to meadow and pasture, there being extensive moors on Pengam, Splott and Adamsdown. All these farms have either been demolished or have been converted for different purposes. The largest landowner in the parish in 1840 was Lord Tredegar (919 acres) followed by the Marquess of Bute (648 acres).

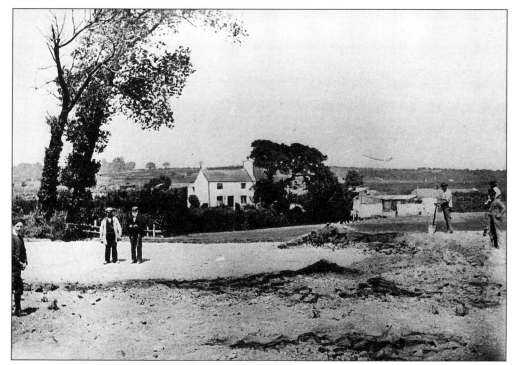

Deri Farm, 1890, viewed from Waterloo Road. 'Deri' means 'oaks' but the property has on occasions been corruptly named as Dairy Farm. It was also known as Roath Brook Farm. It comprised 23 acres in 1840. Demolished in 1909, its name survives in Deri Road.

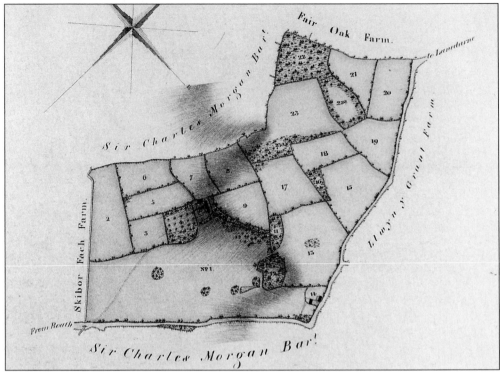

A map of Penylan Farm taken from a Bute estate survey of 1824. The farm covered 115 acres and was alternatively known as Ty Gwyn, the original name. The farmstead became incorporated into the Convent of the Good Shepherd, built at the Marquess of Bute's expense in 1872, for "fallen women". In 1881 there were 99 "inmates" and 17 supervisors there. The convent was demolished in the mid-1960s for the new Heathfield High School, now St David's R.C. Sixth Form College. The farmland was also developed in the late nineteenth century for other 'grand' houses for the business and mercantile classes: Hillside, Wellclose, Oldwell, Bronwydd, Pen-y-lan House, Greenlawn, Fretherne, Linden, Shandon, Craigisla (Tal-y-Werydd) and Birchwood Grange.

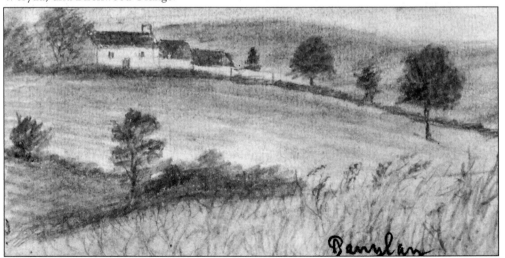

Penylan Farm, c. 1900, from the W.H. Booth collection of South Glamorgan County Library.

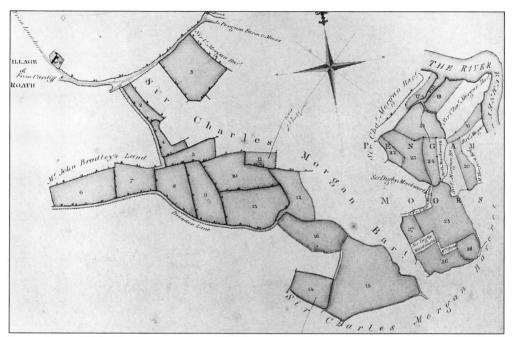

Deans Farm, 1824. Also known as Dean(s)field, Great Barn Farm or Ysgubor Fawr. It was in the ownership of Anthony Dean from 1788 until at least 1820. The farmstead stood directly opposite Roath Court, near the church, though its fields were dispersed, with 117 acres lying south of the Newport Road, primarily on Pengam Moor. Brindon Lane appears in a ministers' account of 1492 and ran in part south-east of the South Wales Railway close to where the northern boundary of Splott Park, Cameron and Swinton street runs today.

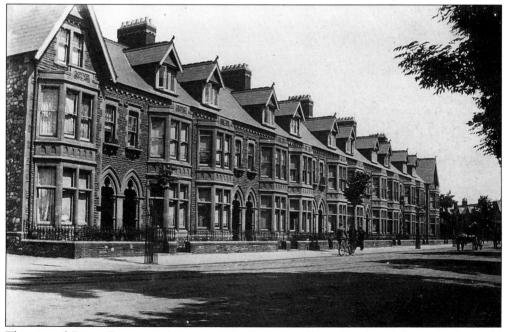

The site of Deans Farm, c. 1910, now Nos 281-303 Albany Road, and formerly Deanfield Terrace (built 1906 and renamed c. 1930).

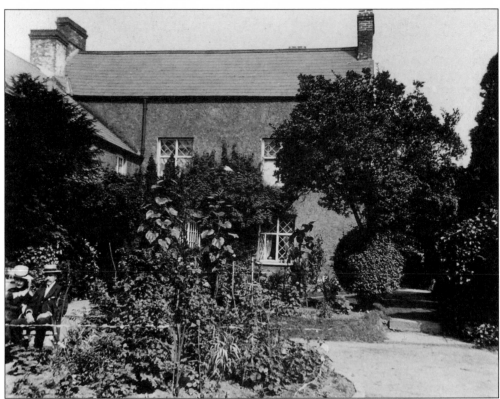

Two views of Deans Farm, 1890. In 1891 the farm comprised a household of seven headed by the 59-year-old widow Mary Evans, two daughters, Katie and Florence, a son Ivor, two grand daughters Gladys and Mildred, and a servant Agnes Martin. The Evans family had lived there since at least 1840. The property was demolished in 1905.

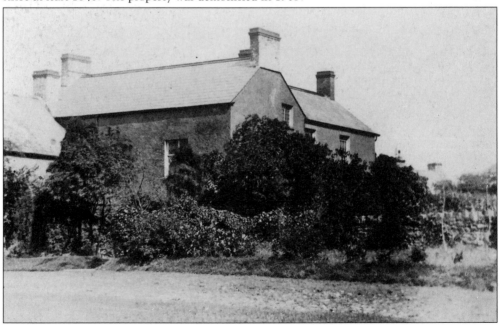

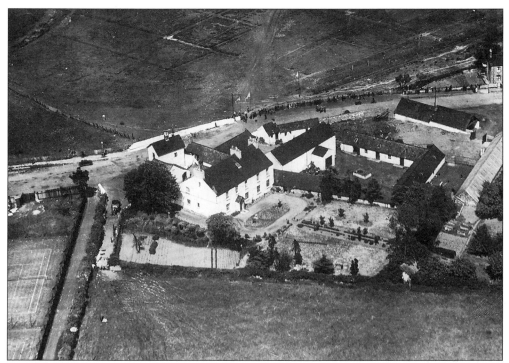

Pengam Farm, June 1930. The municipal aerodrome lay close by, which probably accounts for the large number of onlookers.

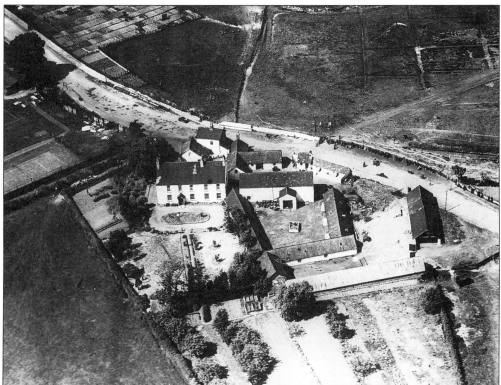

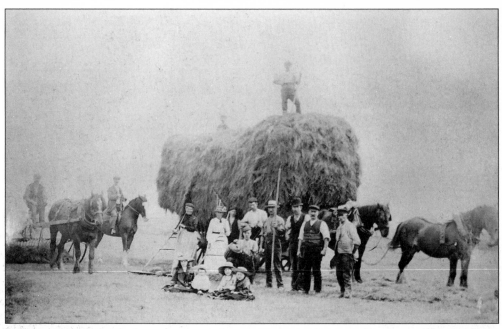

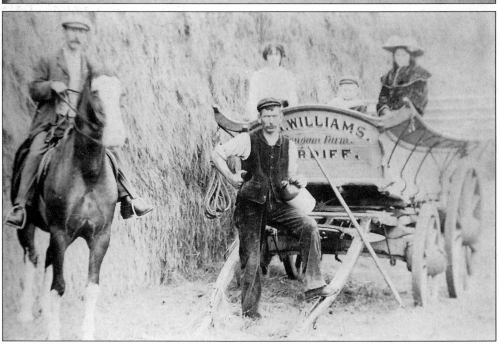

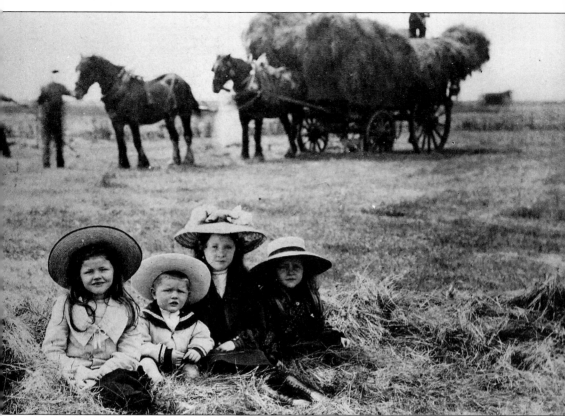

Haymaking on Pengam Farm, 1906. The photographs *opposite* are of John Morris and his workers, and *above* of his children, Violet, Ivy, Eva and Edgar. Morris was the manager of the farm who reported to Thomas Glyndwr Williams. Pengam Farm was the second biggest in the parish at 351 acres and formed part of the Tredegar Park estate. In the seventeenth century it was the abode of the Meredith family. William Meredith's probate inventory of 1694 describes a two-storeyed property comprising, on the ground floor, a parlour, hall and kitchen, and, on the first floor, a chamber over the hall, chamber over the parlour and chamber over the entry. At the time of his death Meredith owned 207 sheep and 50 lambs, the largest recorded in the parish, all of which would have grazed on the extensive Pengam Moor. In 1850 the railway passed through Pengam farmland more or less parallel with Newport Road, and cut across the access road from the latter to the farmstead. Twentieth century developments include the Cardiff Municipal Airport (1930), the Tremorfa housing estate (particularly since 1945) and the Willows High School (opened 1967). The farmstead fell vacant in 1936/7 and was subsequently demolished.

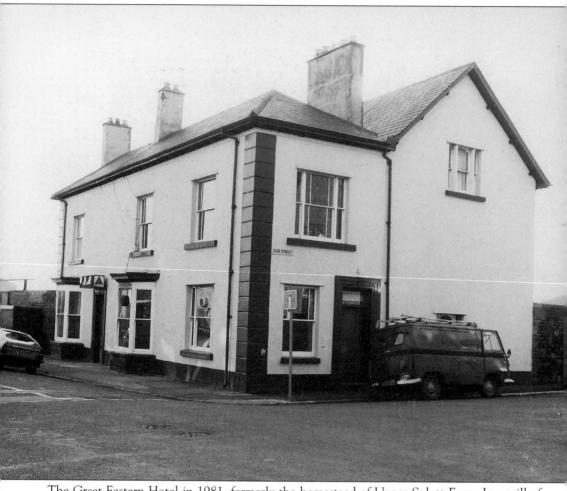

The Great Eastern Hotel in 1981, formerly the homestead of Upper Splott Farm. In a will of 1701 the property is described as comprising: passage, buttery, red chamber, brew-house, dairy, white chamber over the hall, room over the passage, room over the red chamber, two rooms over the kitchen, room over the white chamber, upper room over the passage and upper room over the kitchen. In 1840 the farm was 378 acres but this included the Lower Splott Farm (both worked as one unit). It was the largest holding in the parish, although, like Pengam, an extensive area was moorland. Splott had originally been an episcopal estate of the Bishop of Llandaff, supposedly before the Norman conquest of Glamorgan. Since the thirteenth century it had been leased to the Bawdrip family of Odyn's Fee (Penmark Place). Shortly before 1600 the farm became divided into the upper and lower portions. In 1626 Splott (or part of it) was sold to Sir Edward Lewis of the Van, Caerphilly and passed to the Morgans of Tredegar Park c. 1676. The name Great Eastern is, no doubt, derived from Brunel's ship the *S.S. Great Eastern* which was launched in 1858 and was the largest steamship of her day. Urban development of the farmland also began around this time.

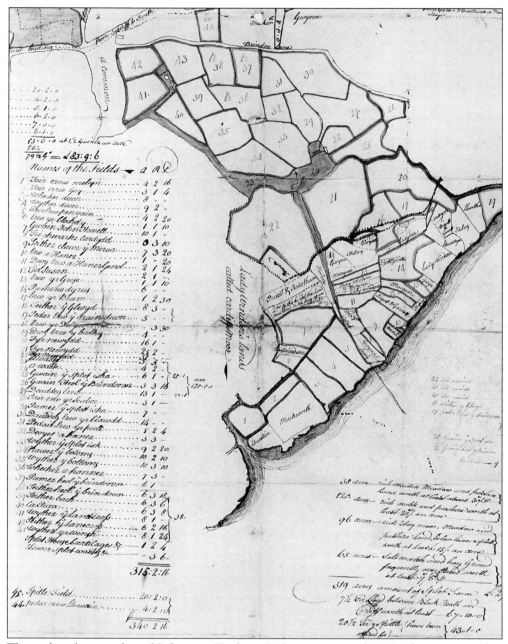

The earliest known plan of Splott – a Tredegar Park estate map of 1777. The tenant at that time was William Harris, who paid an annual rent of £300. The Upper Splott farmstead lies between plots 41 and 43, while the Lower Splott buildings are surrounded by plots 24, 33, 29 and 28. The numbered plots were those belonging to the farm, the unnumbered plots are neighbouring estates labelled with their owners' names.

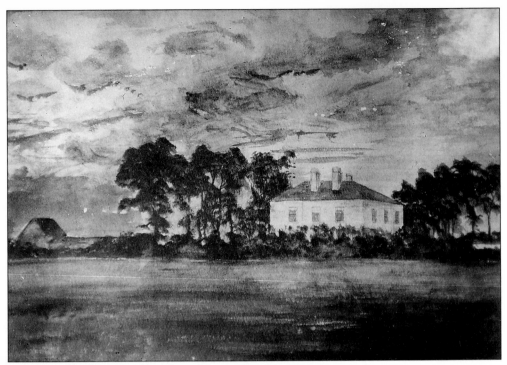

An 1890 view of Lower Splott Farm by an unknown artist.

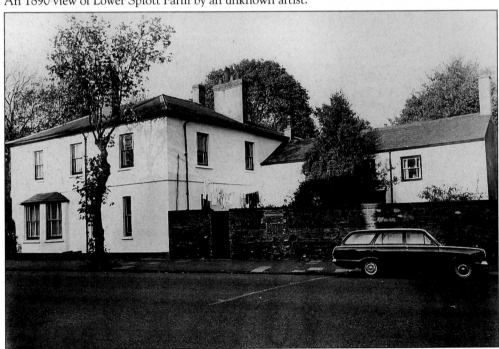

St Saviour's vicarage, 1981. Formerly the Lower Splott Farm, this two-storey villa was converted into a vicarage in 1915. The main front faces Courtenay Road. It is a Grade II listed building on account of it being "a stylistically distinctive building for this area". The former Dairy Cottage is also shown.

Four

Houses

There were no gentry residences in Roath to match the grandeur of the 'great houses' of the Vale of Glamorgan. The principal residences were Roath Court, Plasnewydd, Ty Mawr, Longcross House and Adamsdown House. Only Roath Court and Plasnewydd (as a funeral home and sports and social club/residents' centre respectively) survive today. The 1850s and 1860s also saw the development of villas in the Newport Road and Wordsworth Street (later Avenue) areas though many of these have now been demolished as have some of the grand establishments built from the 1870s in Penylan as homes for the newly emergent mercantile and business classes.

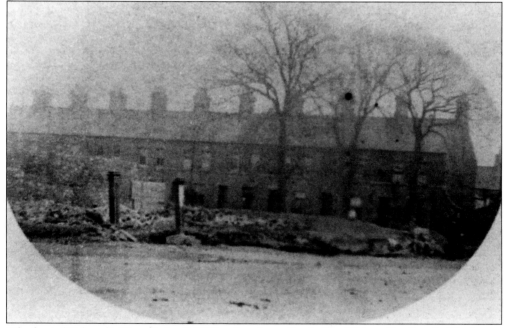

'The last of Talworth House', April 1891, taken from Castle Road (later City Road). The house was not named in the 1851 census, but the following year it is given as the address of John Batchelor, shipbuilder and the 'Friend of Freedom', in Scammell's directory. Later residents included James Hemingway and Charles Pearson of the firm Hemingway & Pearson, well-known contractors. James Street (renamed Talworth Street in 1891) is presumed to be in the background. Pearson Street developed from 1890.

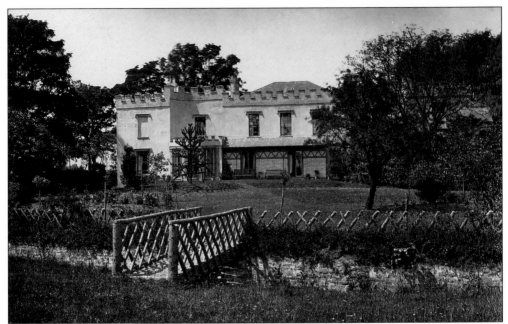

Plasnewydd mansion, *c*. 1880, showing, *above*, the garden on which the later bowling green of the Mackintosh Institute was developed. There was a property on this site from at least 1782, but it was not called Plasnewydd until after 1834. It was also known as Roath Lodge (1824) and Roath Castle (1829) on account of its crenellated features. Evidently at one time part of the Roath Court estate when advertised for sale as Roath Lodge in 1824 it was described as a "Modern Villa containing Dining and Drawing rooms, excellent Bed-rooms, [and] every necessary attached Office...". It came into the ownership of John Matthew Richards in the early 1830s, from whose family it passed by marriage (1880) to the Mackintosh of Mackintosh.

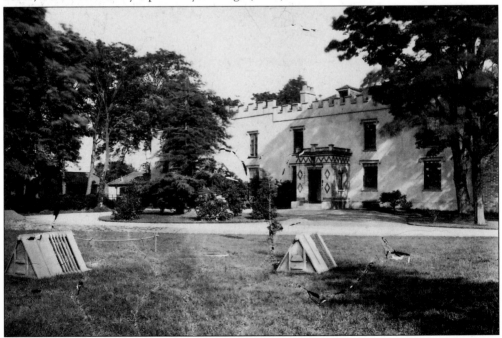

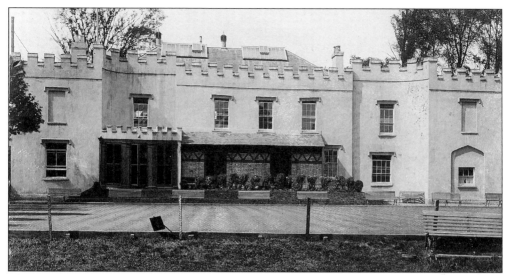

The Mackintosh Institute in 1906. It had been formally opened on 6 June 1891. Plasnewydd and two acres of land were donated by Mr & Mrs Mackintosh to the residents of the newly developed Mackintosh estate in 1890 for leisure and recreational use. The principal residence of Mr & Mrs Mackintosh in South Wales was Cottrell Mansion, St. Nicholas, though the ancestral home was at Moy Hall, Inverness-shire.

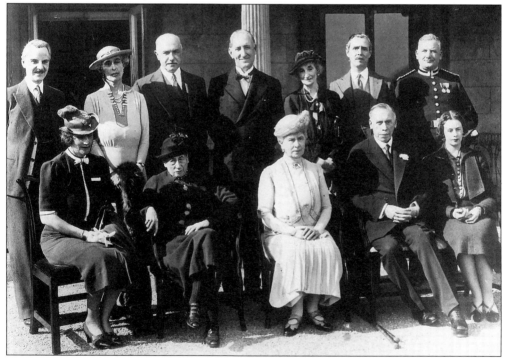

Cottrell Mansion, April 1938. From left to right, seated: the Countess of Plymouth, Mrs Mackintosh, Queen Mary, the Mackintosh of Mackintosh, Miss Mackintosh. Standing: Sir Gerald Chichester, Lady Cynthia Colville, Lord Stanmore, the Earl of Plymouth, the Dowager Countess of Plymouth, Lord Gerald Wellesley and Joseph Jones, the Chief Constable of Glamorgan. The Mackintosh had been a great friend of George V.

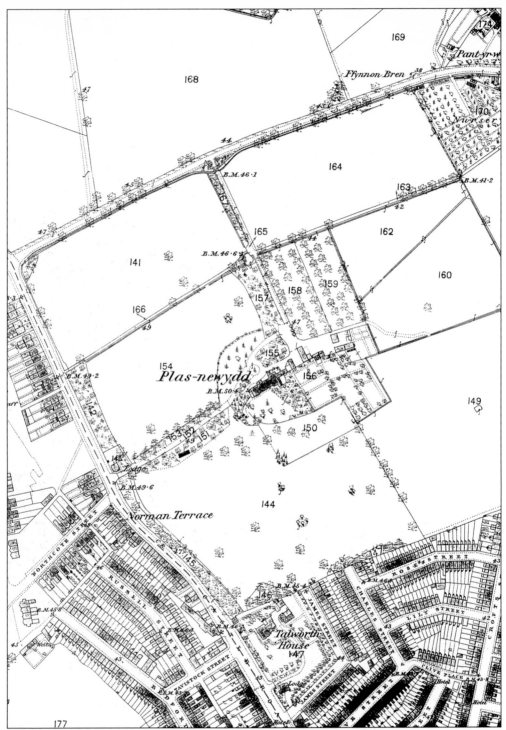

Plasnewydd and Talworth House in 1880. Several of the streets were renamed in 1891 following the demolition of Talworth House. James Street became Talworth Street, Clive Street became Byron Street and Charles Street became part of Plasnewydd Road.

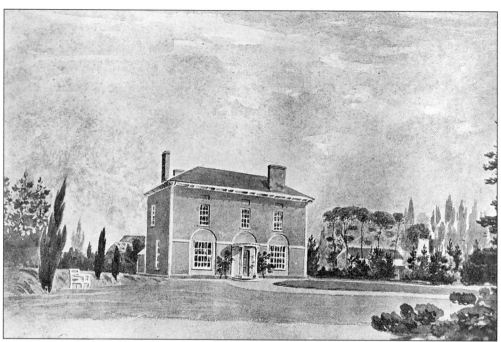

Above: Roath Court, 1826 (artist unknown); *below*: a sketch by John Hobson Matthews, *c.* 1903. This eighteenth century mansion occupied an ancient site – the manor house of Roath Dogfield. An older building, fortified and moated, was recorded as ruined in the reign of Elizabeth. The estate was heavily mortgaged in the late eighteenth century and was eventually sold in 1811-12 to John Wood, a Cardiff banker and attorney. It was advertised for sale in 1824 and subsequently acquired by Mrs Anne Williams, the mother of Charles Crofts Williams. It remained in the ownership of the Williams family until 1953, when it was bought by Morlais Summers who established the funeral home that occupies the site today.

Valuable Freehold and Copyhold Estates and Mineral Property.

Particulars

OF SUNDRY VERY VALUABLE AND DESIRABLE

ESTATES AND MINERAL PROPERTY,

SITUATE IN AND NEAR TO THE

TOWN OF CARDIFF,

AND IN THE COUNTIES OF

GLAMORGAN, MONMOUTH, AND BRECON;

COMPRISING A SUBSTANTIAL

Well-Built Family House,

SUNDRY MESSUAGES AND TENEMENTS ELIGIBLY SITUATE IN

THE TOWN OF CARDIFF;

The Mansion Houses called Roath Court and Roath Lodge, with Lands adjoining, situate near to Cardiff;

THE TY YN Y COED FARM ADJOINING ROATH LODGE.

Sundry Farms and Estates and Mineral Property

IN THE PARISHES OF ROMNEY, PETERSTONE, BYSALEY, LAN-DAFF, LANTRISSENT, LANVABON, YSTRADYFODOG, LAN-WONNO, ST. BRIDE'S MAJOR, AND LLANWERTID;

Which will be Sold by Auction,

BY MR. PEYTON,

IN TWENTY-SEVEN LOTS,

AT THE ANGEL INN, IN THE TOWN OF CARDIFF,

on Saturday, the 14th day of February, 1824,

BETWEEN THE HOURS OF 2 AND 4 O'CLOCK,

Subject to such Conditions of Sale as shall be then produced.

BY ORDER OF ASSIGNEES UNDER A COMMISSION OF BANKRUPT.

Roath Court estate sale catalogue, 1824. The "capital mansion house" of Roath Court is described as containing "Breakfast-room, Dining and Drawing-rooms, capital Kitchens and Cellars, … seven best Sleeping-rooms, and four others for Servants, Entrance Lawn and Shrubbery, Walled Gardens well planted, small Green-house and Gardener's House, Five-stall Stable, Coach-house and Dog-kennel, Farmyard, Barn, Cart Stable, waggon Lodge … and Five Workmen's Cottages".

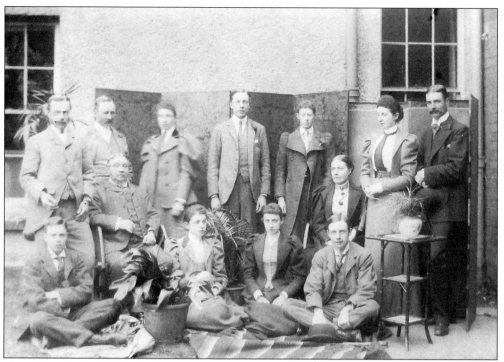

The Williams family outside Roath Court, *c.* 1895. From left to right, standing: George Crofts Williams, Hastings Clay, Mabel Clay, Charles Crofts Williams II, Maud Williams, Blanch Homfray, Herbert Homfray. Seated: Charles Henry Williams, Millicent Frances Williams. Floor: Claude Williams, Diana Williams, Rose Williams, Robert Henry Williams.

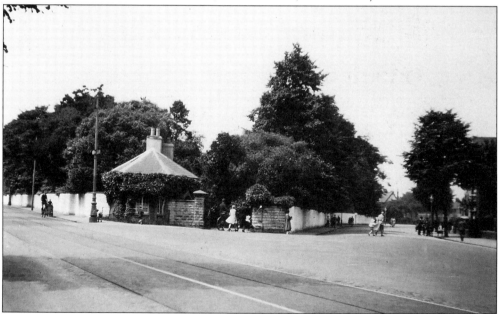

Roath Court lodge, 1933, at the junction of Newport Road and Albany Road. The lodge was acquired by the City Council in 1936 and subsequently demolished as part of a road-widening and tram-track doubling scheme.

Ty Mawr (Great House), otherwise Llys Ddu, pictured shortly before demolition in January 1967. It is now the site of the Ty Mawr Old People's Home. Probably of late sixteenth or early seventeenth century construction, it seems likely that it was occupied during the whole of the latter by a cadet branch of the Stradling family of St Donat's. A 1689 inventory of Blanch Lewis, the daughter of Lambrook Stradling of Roath, describes a two-storey property comprising parlour, hall, kitchen, buttery, old buttery, outward kitchen, dairy, granary, storeroom, brewhouse, new chamber, blue chamber, nursery, middle chamber, kitchen chamber and chamber over the old kitchen. By 1698 the house belonged to Sir George Howells of Bovehill, St Andrew's Major parish. It later became part of the Tredegar Park estate.

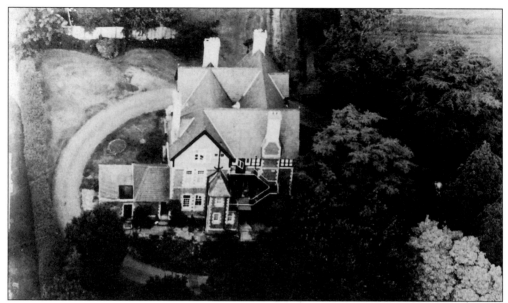

Wellclose, Penylan. Built in 1886, Thomas W. Jotham, woollen merchant, was the first resident. From 1903 to 1932 it was occupied by H.B. Marquand, a member of a distinguished family of ship brokers, coal exporters and steam tug owners. The property became an old people's home in 1947 and remained so until its closure in 1987 and subsequent demolition. The site is occupied today by Stonewell Court (housing association flats) and part of Oldwell Court Day Centre, opened in 1991.

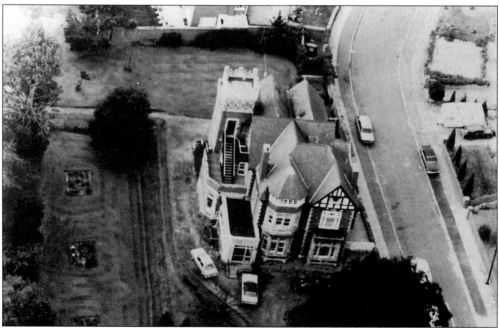

Oldwell, Penylan. Built in 1887, it adjoined Wellclose. It was for many years the home of William Young, a wealthy Cardiff potato merchant. Like Wellclose it became an old people's home (early 1960s). It closed in 1987 and was later demolished. It is now the site of Redwell Court (housing association flats) and part of Oldwell Court Day Centre.

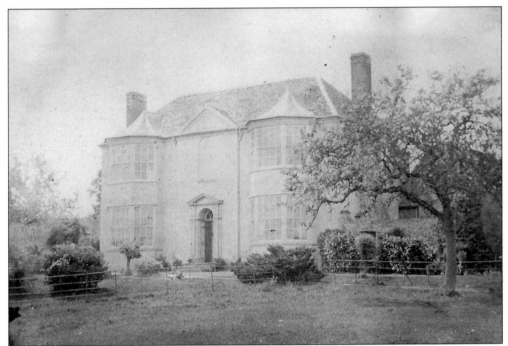

Bronwydd, Penylan, c. 1900. One of the first large villas to be built on Penylan hill. Occupied in 1871 by Daniel Thomas, a successful public works engineer and contractor, it subsequently passed to his son Sir Alfred Thomas M.P. (later lord Pontypridd). It was demolished c. 1970 to make way for the Eastern Avenue bypass. The Penylan wishing well was within its grounds.

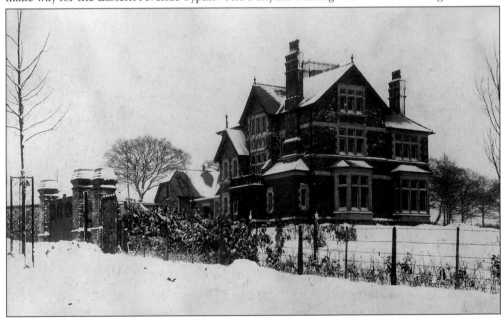

Fretherne, Penylan, 1896. Soon after it was built it was the residence of John Hollingsworth Corfield, shipowner. Corfield moved to Cathedral Road in 1901 and the house was bought by the shipowner, F.B. Woodruff, who renamed it Hartlepools. By 1921, however, it was known as Woodlands. It was demolished in the late 1950s and the grounds are now part of White Lodge.

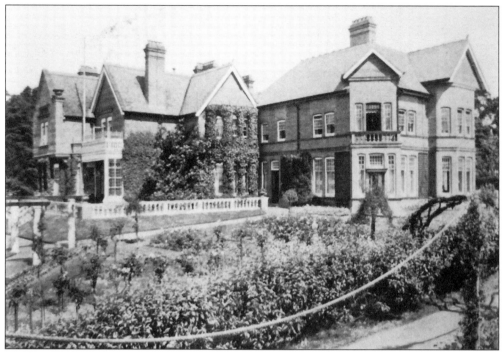

Birchwood Grange in 1924, the residence of Sir William James, Baronet, colliery proprietor. Built *c*. 1890, the first person to take up residence here was Charles J. Jackson, architect, barrister and a Fellow of the Society of Antiquaries. During the Second World War, and immediately after, the building was used by the Inland Revenue. The mansion has been part of University Hall since 1953.

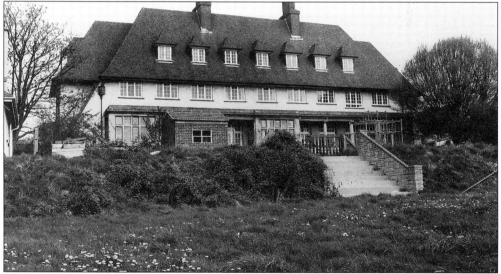

The Edward Nicholl Children's Home in April 1981 shortly before its closure. Not a gentrified villa but purpose-built as a home. The building was made possible by the promise of £20,000 by the shipowner and M.P., Sir Edward Nicholl, providing that a like sum was raised by voluntary effort. This was achieved, and the home was officially opened on 29 November 1922. It closed on 25 July 1981, and was subsequently demolished.

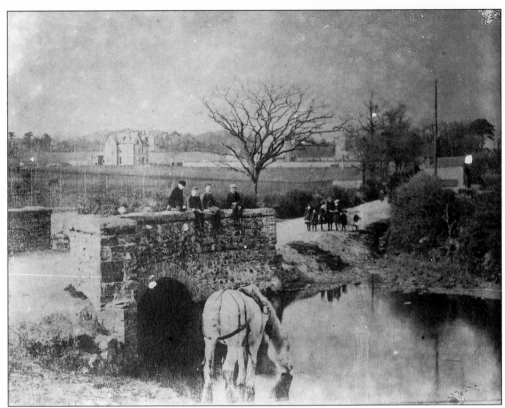

Pont Licky Bridge, 1890, showing in the background, from left to right: Hillside (built *c*. 1888, demolished *c*. 1963), Bronwydd, Wellclose and Oldwell. A new bridge was built in 1892 when Penylan Road was widened.

A pre-1871 cottage behind Elm Street in 1973, when the demolition of a house on the west side of Elm Street exposed it to view. Now modernised, it is known as Rose Cottage.

Five
Churches and Chapels

In the medieval period, St Margaret's was one of several chapels that served St Mary's, Cardiff whose parish was originally co-extensive with the lordship of Cardiff. It was still a chapel in 1563 but was probably accorded parochial status not long after. St Margaret's remained the parish church until the late nineteenth century when in reaction to the growth of population and urbanisation necessitated the creation of new parishes were created – St German's (1886), St Saviour's (1893) and St Martin's (1903). By 1914 there were ten Anglican churches (including mission houses) in the area covered by the old parish as well as St Alban's Roman Catholic Church. The growth of population and influx of immigrants also stimulated non-conformity so that by the First World War all the major denominations were represented and 24 chapels were in existence. Over a third of these were in Splott, considered at one time to be one of the 'darkest' spots in Cardiff. Indeed it had been written that one "might as well try to demolish the fort of Gibraltar with boiled peas as to convert the people of Splott in a [mission] tent"!

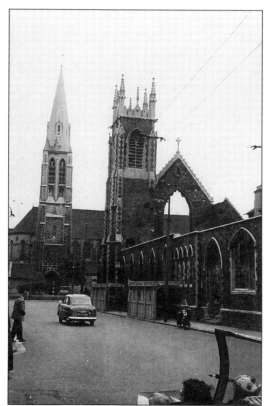

The war-damaged remains of Roath Road Wesleyan Methodist Church, 20 August 1955, shortly before demolition. St James's, Newport Road, lies ahead.

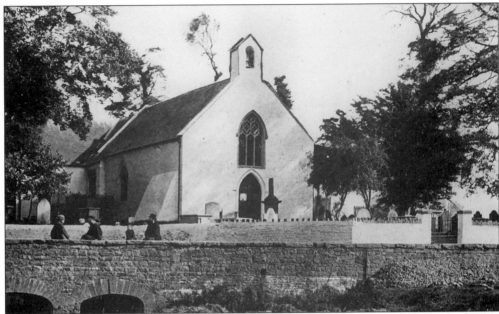

Two views of St Margaret's Church, Roath, 1865. Founded by the Normans in the late eleventh century, St Margaret's was formerly one of several chapels of St Mary's, Cardiff, and, like the latter, belonged to Tewkesbury Abbey until the dissolution of the monastaries in the 1530s. It was still a chapel in 1563. Dedicated to St Margaret of Antioch, this church was demolished in 1869.

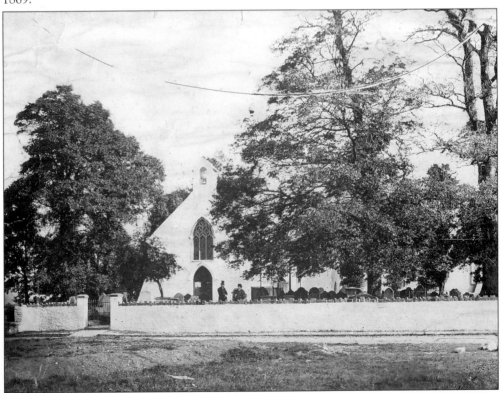

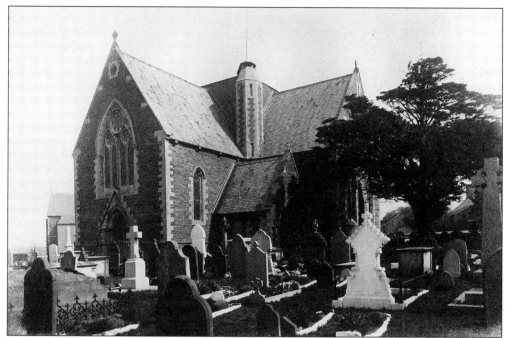

St Margaret's Church, May 1891. Designed by John Prichard, the new church opened on 10 July 1870. Financed totally by the third Marquess of Bute, it was thought that his 'sudden' conversion to Roman Catholicism during the rebuilding prevented the completion of the tower (added 1926), though doubt has recently been cast on this theory. Nearly all the gravestones were removed in 1961, one of the few remaining is the large slabbed one to the far left under which several of the Williams family of Roath Court are buried.

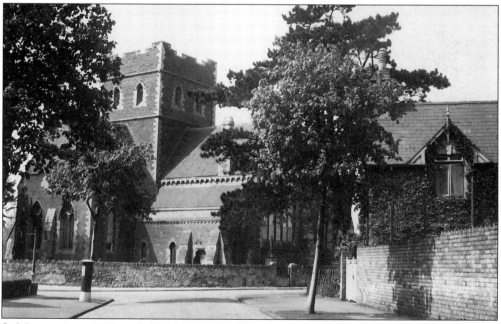

St Margaret's, c. 1960, with Ty Mawr in the foreground.

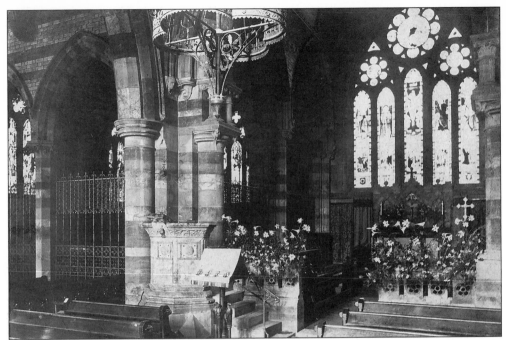

St Margaret's interior, 1906. The semi-octagonal pulpit has some fine detail while the simple vault that had housed the Bute tombs since 1800 was transformed into a forbidding mausoleum, shown left, between 1881 and 1886. Nine members of the Bute family, including the first marquess and his wife, are interred here.

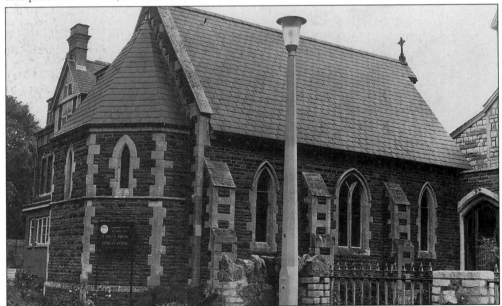

St Teilo's Priory Chapel, Church Terrace, 1965. It was originally the chapel of St Margaret's House of Mercy (opened 1882) and was run by the Society of St Margaret's, an Anglican order of nuns centred in East Grinstead. The building on the left was the children's home opened in 1894. When the sisters left in 1934 the whole site continued to be used for various religious purposes until 1978, when it was placed on the market.

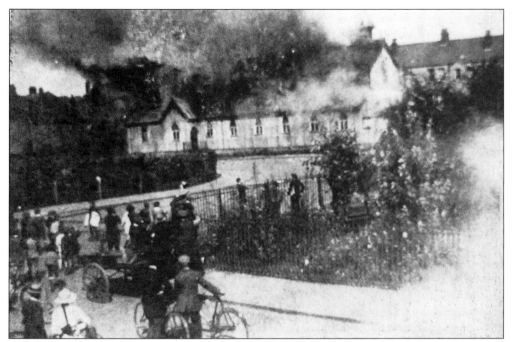

St Edward's Church, Blenheim Road, on the night it was destroyed by fire, 11 September 1919. It had been opened as a daughter church of St Margaret's only a few years previously in March 1915. A new church was opend here on 30 November 1921.

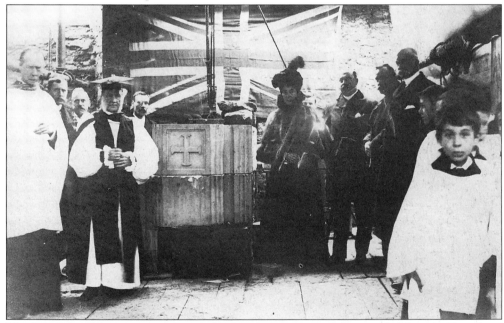

Mrs S.A. Brain (the Mayoress) laying the foundation stone of the new St Martin's Church on 16 December 1899. Also present were Canon Beck, vicar of Roath; J.W. Courtis, broker; George Beames builder; the Bishop of Llandaff; the Mayor (Cllr. Brain) and Lord Tredegar. Originally founded in 1886 as an iron church and dedicated to St Martin of Tours, it was re-consecrated on 20 October 1901.

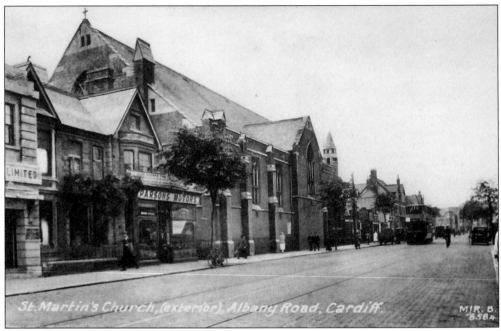

St Martin's Church on Albany Road, 1920, showing, *above*, the exterior, and, *below*, the elaborately painted interior. The church was built on Mackintosh estate land and was designed by F.R. Kempson. The interior was destroyed in the blitz, the church being restored in 1955. It had become a separate parish, served by St Cyprian's, Monthermer Road, in 1903.

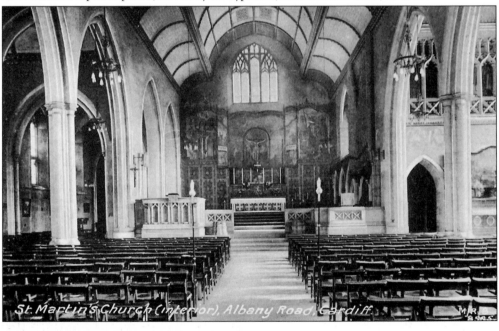

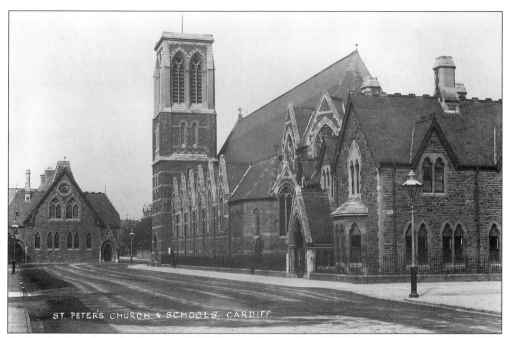

St Peter's Church and schools, *c.* 1910. It was designed by C.F. Hansom and opened in 1861. Originally known as St Peter's in the Fields, the tower was completed in 1883. The school, to the left, was built in 1872 and demolished in 1981.

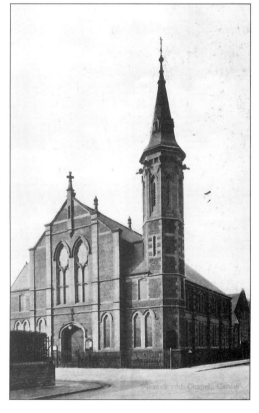

Plasnewydd Presbyterian Church, 1907. A Sunday school was started in Richmond Road in 1885 and in 1886 a school chapel was erected in Keppoch Street. The church, designed by W.B. Rees, was opened on 3 November 1901 adjoining the school chapel. The first pastor was the Rev. Francis Jones, of whom it has been written: "he brushed his hair up from both sides of his head to meet on the crown, where things were not so flourishing".

NEW PRESBYTERIAN CHAPEL

(ENGLISH CALVINISTIC METHODIST),

PLAS NEWYDD SQUARE,

CASTLE ROAD, ROATH.

IN CONNECTION WITH THE ABOVE THE

MEMORIAL STONES

WILL BE LAID ON

WEDNESDAY, JULY 28TH, 1886,

AT 3 O'CLOCK IN THE AFTERNOON, BY

ALFRED THOMAS, ESQ., M.P.

Mrs. JOHN MORGAN, The Parade.

ANDREW FULTON, ESQ.

EX-MAYOR.

AFTER WHICH CEREMONY

A TEA MEETING

WILL TAKE PLACE IN A LARGE

MARQUEE.

TEA ON THE TABLES AT 4 O'CLOCK. TICKETS—ONE SHILLING EACH.

IN THE EVENING AT 6:30

A PUBLIC MEETING

WILL BE HELD

REES JONES, ESQ., J.P.,

WILL PRESIDE.

ADDRESSES WILL BE DELIVERED BY VARIOUS MINISTERS INCLUDING THE

REV. J. CYNDDYLAN JONES, D.D.

Revs. J. Pugh, Pontypridd, D. W. Davies, Newport, E. Griffiths, H. J. Hughes, Merthyr, Josiah Thomas, W. Francis Jones, Moses Williams, Bridgend, and others.

A CONTINGENT OF THE

CARDIFF BLUE RIBBON CHOIR

Will be present, and render a Selection of Music, under the Leadership of Mr. JACOB DAVIES.

7. & R. ROBERTS, PRINTERS.

The laying of memorial stones for Plasnewydd Presbyterian Church took place on 28 July 1886. The building was erected on Mackintosh estate land.

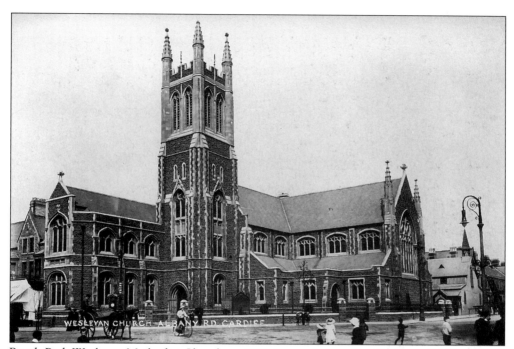

Roath Park Wesleyan Methodist Church, *c.* 1910. It was designed by J.P. Jones, Richards & Budgen and opened on 23 November 1898. It was extended and altered in 1911. The church closed in 1990 and underwent conversion to an indoor market the following year. The building to the right was presumably the iron church erected in 1893.

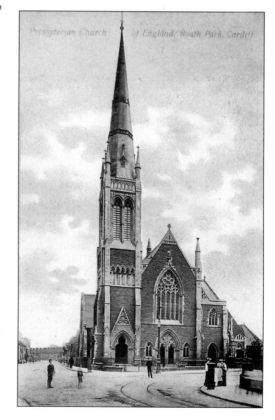

Roath Park Presbyterian Church, *c.* 1910. It was designed by E.H. Fawckner and opened on 20 June 1900. Its spire is 150 feet high and its west front is modelled on Tintern and Melrose abbeys. It is now St Andrew's United Reformed Church.

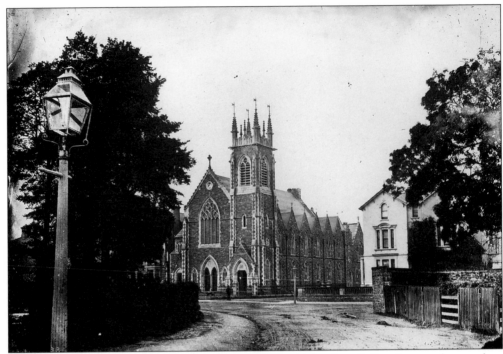

Roath Road Wesleyan Methodist Church, designed by Habershon & Fawckner and opened on 24 May 1871, seen here *c.* 1872. It was extensively damaged by enemy action on 3 March 1941 and was demolished in 1955. Roath Road was renamed Newport Road in the early 1880s but the church retained its original name. The building to the right is Longcross House. Compare this photograph with that on page 104.

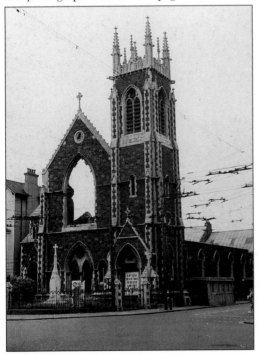

Roath Road Wesleyan Methodist Church on 20 August 1955, just before demolition. The site was subsequently occupied by the Longlife Battery Company and since 1972 by Heron House. Roath Road was the 'mother' to Broadway, Splott Road and Roath Park Wesleyan Methodist churches.

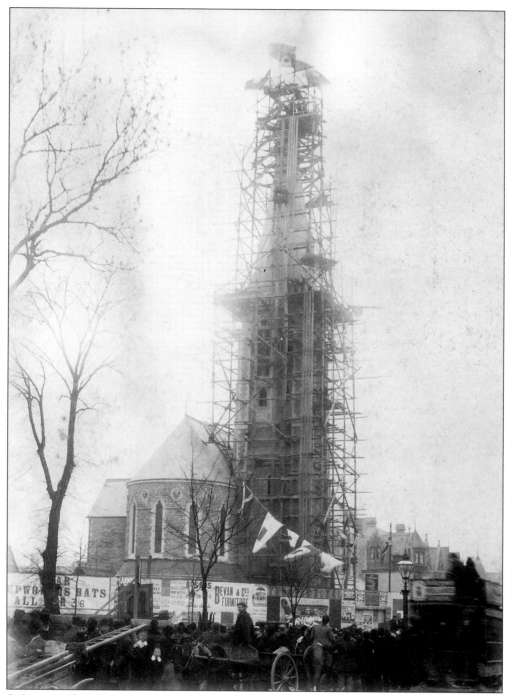

St James's Church, Newport Road, showing Mrs Canon Thompson descending from the spire after putting on the vane, 27 November 1893. Designed by E.M. Bruce Vaughan, it was consecrated on 15 June 1894, replacing an earlier iron building.

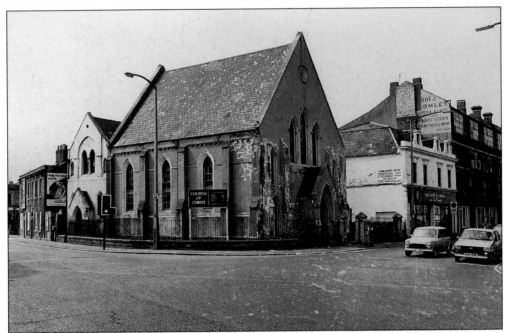

Church of Christ Meeting Place at the junction of Moira Terrace and Meteor Street, June 1982. The site of a baptist chapel from 1861, it became Salem Welsh Baptist Chapel from 1877 until 1972. It was advertised for sale in 1987 and demolished in 1991.

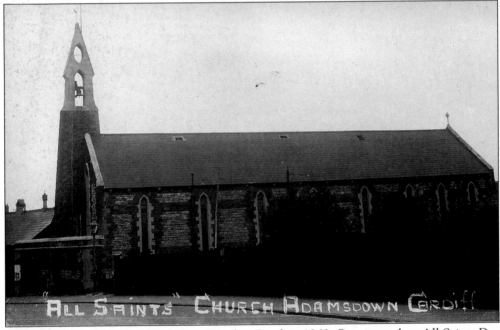

All Saints Church, Adamsdown, from Windsor Road, c. 1960. Consecrated on All Saints Day 1903, the first church was in Tyndall Street at the junction with Ellen Street. This was opened in 1856 and services continued until October 1899 (demolished early 1980s). The present church has been a commercial premises since 1966, whilst the old Adamsdown burial ground was made into a public garden of rest in 1948.

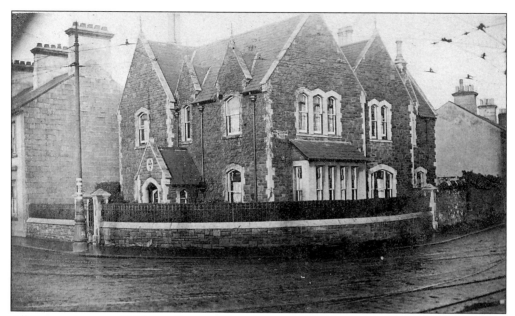

All Saints vicarage, 42 Meteor Street, Adamsdown, at the junction with Constellation Street, c. 1910.

Clifton Street Welsh Calvinistic Methodist Chapel, 1905. It was founded as a lecture hall (Libanus) in 1868. The gothic chapel fronting Newport Road was built in 1880 and from that date English became the main language used in services there. Derelict for many years, it has recently been acquired for use as an arts centre.

Broadway Wesleyan Methodist Church, *c*. 1950. It was built in 1879-80 having been preceded by a mission hall in John (later Nora) Street in 1872. It closed in 1950 when the congregation merged with Newport Road and Roath Road to form Trinity Methodist Church. The premises were sold to the B.B.C. for £7,000, subsequently becoming a warehouse and eventually, in 1980, a mosque. The building was destroyed by fire on 19 September 1989.

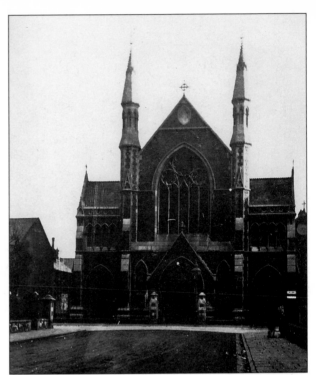

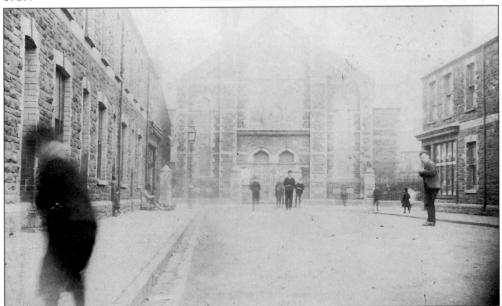

Diamond Street Bible Christian Chapel in 1892, as seen from Topaz Street. It was opened on 18 July 1879 and had a very similar facade to the Star Street Congregational Church, opened in 1871. The Bible Christians are an almost forgotten denomination, having been brought to Cardiff by immigrants from the West of England. Nationally, the denomination ceased to exist in 1907 when it merged with two other Methodist splinter groups. The chapel was demolished *c*. 1980 having latterly been used as a furniture warehouse. Clifton Mews stands on the site today.

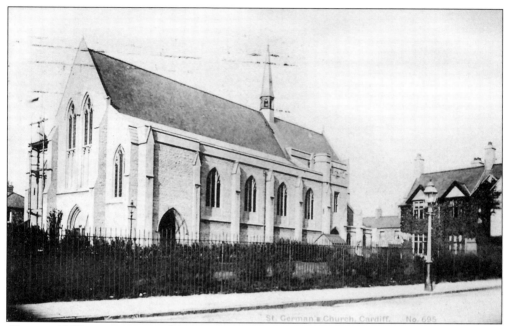

Above: a 1907 exterior view of St German's Church. Dedicated to St German of Auxerre, a Dark Age Celtic saint, it was designed by G.F. Bodley and built between 1882 and 1884 on what had been Upper Splott farmland. It opened on 1 October 1884 and replaced St German's mission established in 1874, which had earlier superseded Christ Church or the Splott Chapel in use since 1857. The parish of St German's was created on 21 December 1886. The building to the right is the clergy house (Metal Street) opened on 24 April 1894. *Below*: St German's interior. Architecturally it has been described as "nothing short of a masterpiece". The reredos was erected as a memorial to the thirty years incumbency of Father Ives, the first vicar.

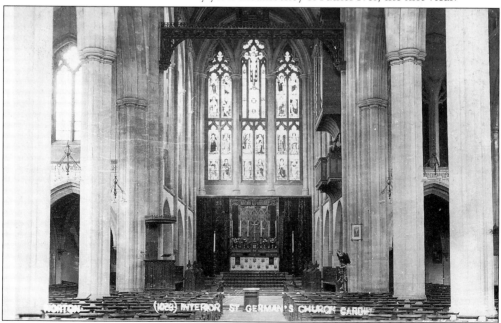

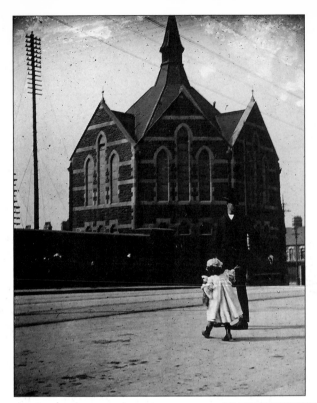

Mount Hermon Primitive Methodist Church, Pearl Street, 1895. Opened in 1892, from 1916-17 it became the Salvation Army Splott Bridge Citadel, and remained so until the early 1980s. The adjacent Splott Road bridge was (re)opened on 3 August 1899 by Sir Thomas Morel, shipowner.

Salvation Army barracks, Cecil Street, 1894. These were built c. 1890 and continued to be used by the Salvation Army until about 1920. It was subsequently a "Holiness" Mission (1924), a Spiritualist Temple (1927-29), Bethlehem Hall (1937) and the St German's Scouts Hall from at least 1949 until c. 1964. It now houses the Cardiff Aikikai Club, established 1868.

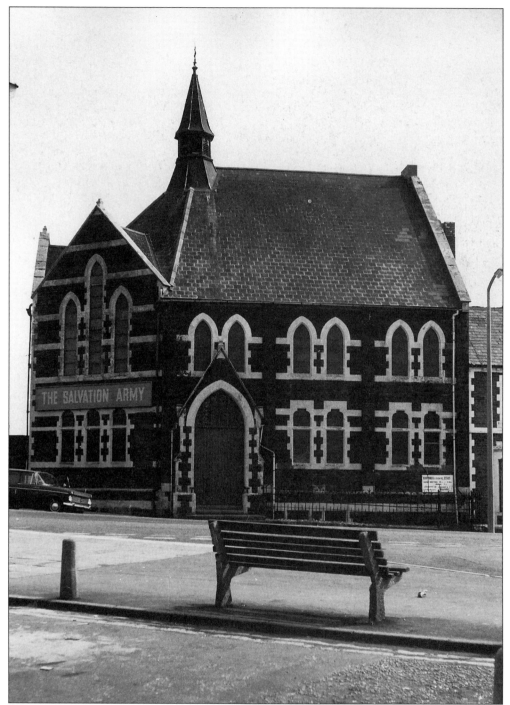

The Salvation Army Splott Bridge Citadel, 1981. It is now Johnson's, a commercial premises.

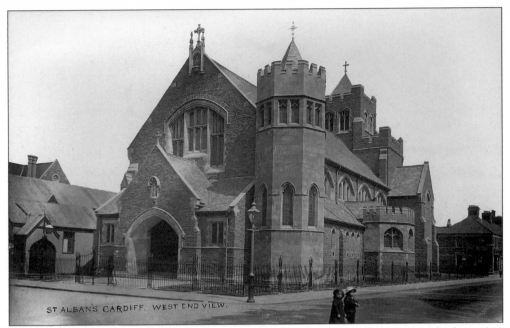

St Alban's on-the-Moors Roman Catholic Church, Railway Street, *c.* 1912. It was built in 1911 athough it had been preceded by an iron church (presumably shown to the left), opened on 30 November 1897 and a school chapel erected in 1891 "in the still unfinished Swinton Street".

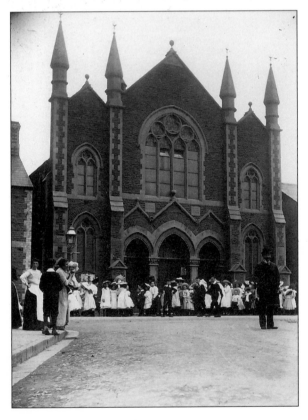

Ebenezer Baptist Chapel, Pearl Street, 1905. It was opened in 1892 although a school chapel had previously been erected in 1888. The foundation stone for the chapel was laid on 4 November 1891 by, among others, Richard Cory, who was described in 1901 as remaining "a generous supporter and staunch friend of the church in Pearl Street". The chapel is now a Sikh temple.

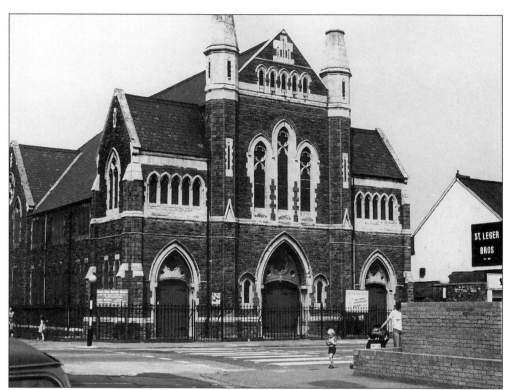

Splott Road Baptist Church, 1982. It was opened in May 1895 (a school chapel had previously been opened on the same site on 11 May 1887). The chapel was demolished in 1983 and the schoolroom adapted for church services. Splott Baptist Court (housing association flats) occupies the site today.

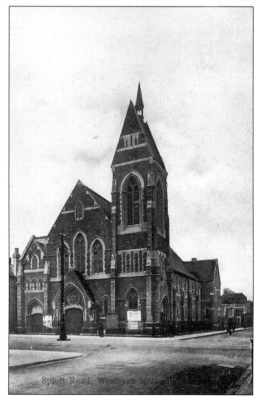

Splott Road Wesleyan Methodist Church, 1905. It was built in 1895 although a school church in the adjoining Habershon Street was erected in 1886. Previously, services were held in people's homes. The church was demolished in 1964 and the primary schoolroom, built in 1908, was converted into a new modern church.

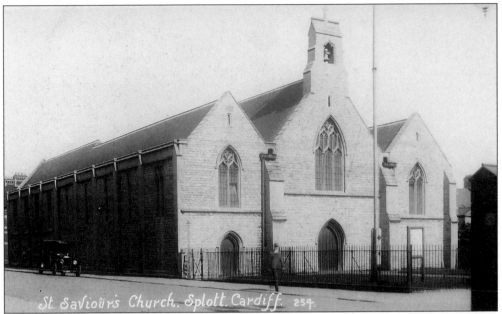

Above: St Saviour's Church, 1925. It was designed by G.F. Bodley. The foundation stone was laid by Lord Tredegar on 28 January 1888 and the church was consecrated on 30 October 1888. The church superseded an earlier iron church as well as the original school chapel of St Columba (off Sanquahar Street) established in 1877. The new parish of St Saviour's was created on 30 January 1893. *Below*: view of the interior. The church was modelled closely on St Mary's, Tenby.

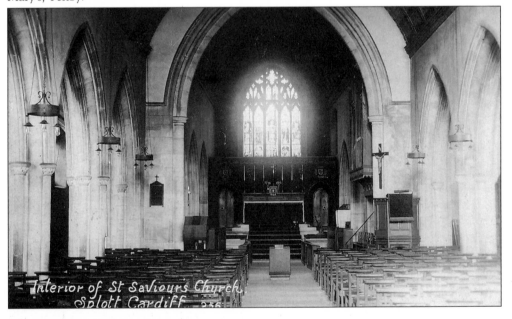

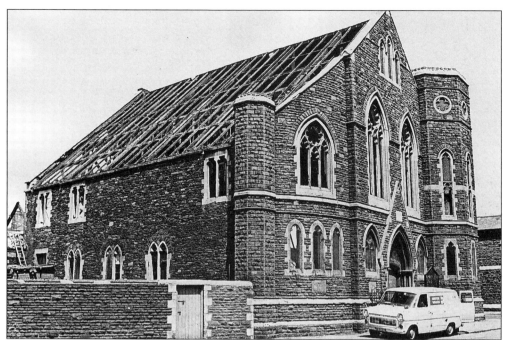

Ainon Welsh Baptist Church, Walker Road, *c*. 1977. It was built in 1895-96 although an earlier mission hall had been established in Marion Street in 1889 – a 'shed' rented by Salem, Adamsdown. Ainon was initially established as a branch of Salem but became a separate baptist church in 1894. It closed in 1975 and was demolished *c*. 1977. Ainon Court, flats erected by the Baptist Union of London, occupies the site today.

Jerusalem Welsh Calvinistic Methodist Church, Walker Road/Marion Street, 1986. It was built in 1902 (an earlier schoolroom opened in 1892) and became 'English' in 1928 when the fellowship at East Moors Hall in Carlisle Street (built in 1892 and now a community education centre) transferred there. Jerusalem was demolished in 1987 and the site was redeveloped by the Moors Community Housing Association.

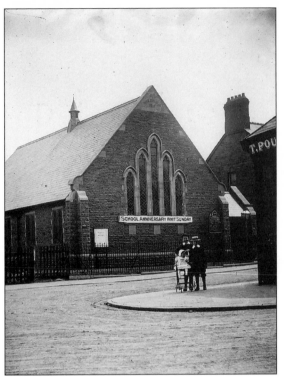

Moorland Road Presbyterian Forward Movement Hall, 1905. Built in 1903-4, it replaced a temporary hall of 1900. The hall was destroyed by fire in 1974 and a day centre for the elderly was opened on the site on 4 July 1978. The Forward Movement was the most remarkable of the many non-conformist missions started in Splott in the 1880s and 1890s. It was started by the Rev. John Pugh, Minister of Clifton Street Presbyterian Church from 1889 to 1892. Like many others he believed that the battle had been virtually lost to evangelise the urban working classes. In 1891 Pugh erected a tent on a vacant lot in Ordell Street, Splott, and began to preach. The mission was an immediate success and in little more than a year East Moors Hall had been built in Carlisle Street with seating for 1000 people. The Presbyterian Church of Wales officially adopted the Forward Movement in 1892.

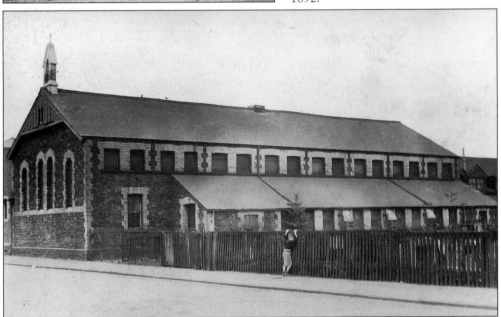

St Francis's Church, Swansea Street, Splott, 1953. It was blessed for use on 4 October 1894. Before that the district had been served by an 'iron church' in Neath Street. That had been opened on 10 December 1889 to meet the needs of workmen and their families, particularly those engaged in the copper and iron works. The last service was held at St Francis's on 14 October 1969 and the building was then demolished to build the Moorland Nursery School opened in 1970.

Six
Education and Health

The growth in population also acted as a stimulus to educational provision. The Roath village school dated from at least 1840 but the 1870s saw the establishment of several school-chapels as well as a board school in Adamsdown. Other board schools were to follow in the 1880s and 1890s. The 1880s also saw the opening of the Glamorgan and Monmouthshire Infirmary and Dispensary (the Cardiff Royal Infirmary today) on land previously in Roath parish. In respect of health generally, some of the photographs in section 7 give us a glimpse of the poverty that was all too visible in the late nineteenth century whilst a reading of the Medical Officer of Health's report to the Roath Board of Health in 1872 reveals the problem of drainage in the district – the result of rapid urbanisation – and its injurious effect on health.

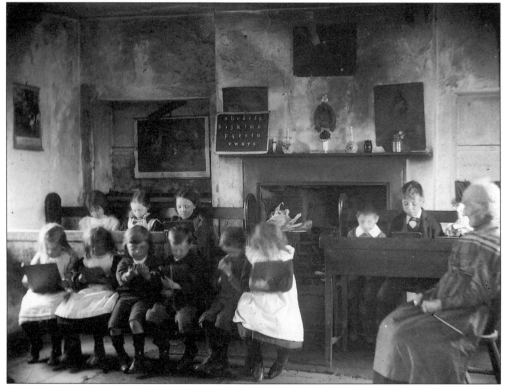

Interior of Roath village school, 1899. It ceased to function as a school *c.* 1902.

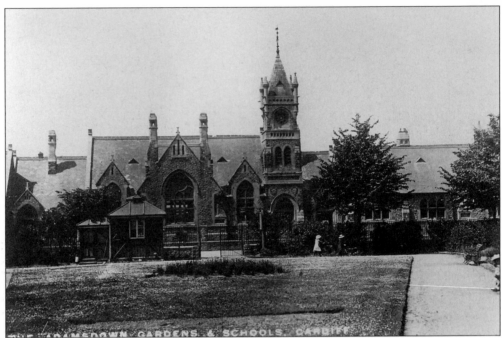

Adamsdown Gardens and Board School, 1906. The school was opened on 31 July 1879 and enlarged in April 1897. It closed in July 1985 and was demolished c. 1988. The gardens formed part of Adamsdown Square, built in 1877 on the Adamsdown estate owned by the Marquess of Bute. Adamsdown Square was one of many gardens and squares given to the Cardiff Corporation by the Marquess (1888).

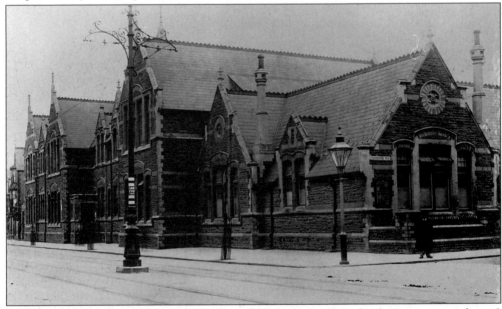

Albany Road Board School, 1903. Built on Mackintosh estate land, it was opened on 2 November 1887 and was later enlarged in 1898. At the end of the first week there were 138 girls and 154 boys on the roll. It was recorded that the girls in Standard I were extremely backward and most of the girls and boys did not know their letters.

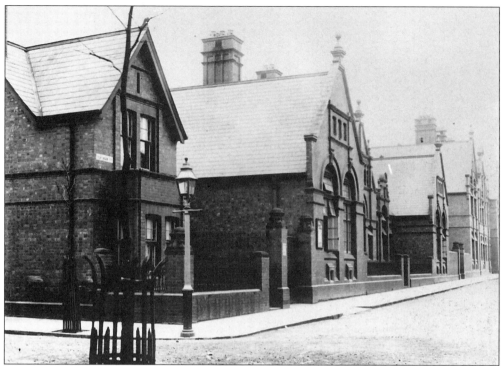

Roath Park Board Schools, 1903. Designed by E.W.M. Corbett, they were built in 1894 on Penywain farmland owned by the Marquess of Bute and were opened on 9 January 1895. Tenders for the work went out on 5 June 1893 and Mr Harry Gibbon of the Steam Joinery Works, 185 Richmond Road won the contract. The school cost some £16,000 to build and accommodated 380 boys, 380 girls and 496 infants.

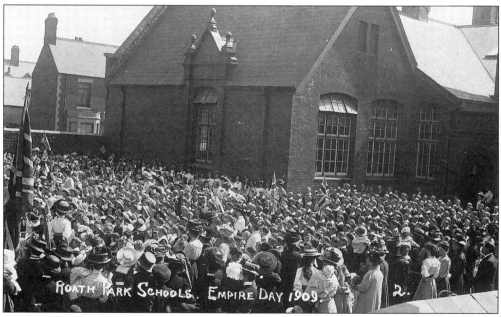

Roath Park Schools, Empire Day 1909.

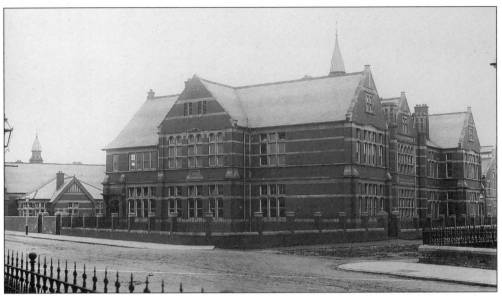

Marlborough Road School, 1903. This was built in 1899 on Tredegar land (Tir Colly Farm, part of the Ty Mawr estate) and opened on 11 January 1900.

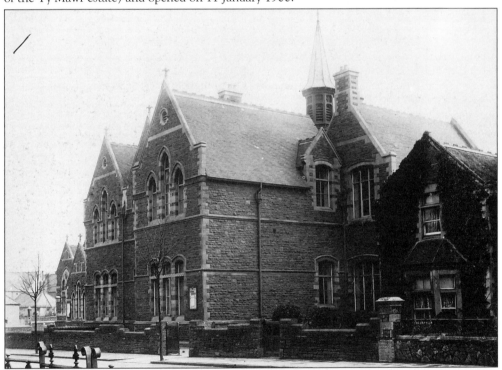

Stacey Road Board School, 1903. This was opened in July 1882 and was enlarged in 1894. It was built on land owned in 1840 by Mrs Mary Charles. This land was alternatively known as 'The Island' or 'Island Farm' ('Yelonde' in 1487). Stacey Road was planned in 1873 and was one of several new streets on 'Island Farm' for the Rev. J.H. & T.E. Stacey, the latter being the brother-in-law of Edward Priest Richards (of Plasnewydd), agent to the Marquesses of Bute. The principal street names in this area bear witness to this relationship.

74

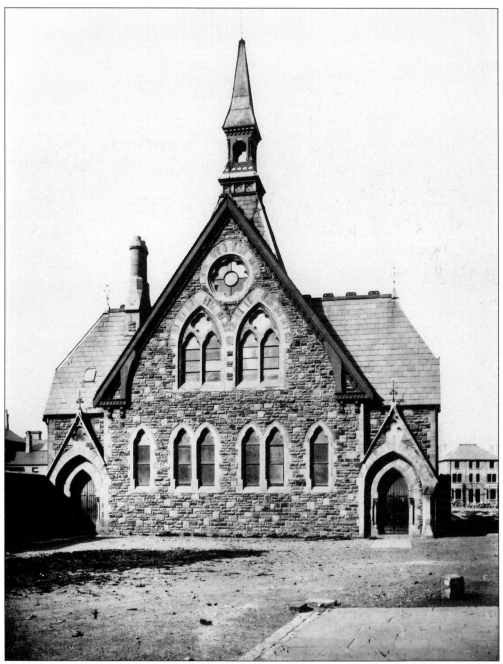

St Peter's R.C. School, St Peter's Street, *c.* 1880. It was founded in 1872 and demolished in 1981, Richmond Court now occupying the site. Note Richmond Road in the background. The latter was developed in the late 1870s and early 1880s by Charles Henry Williams of Roath Court.

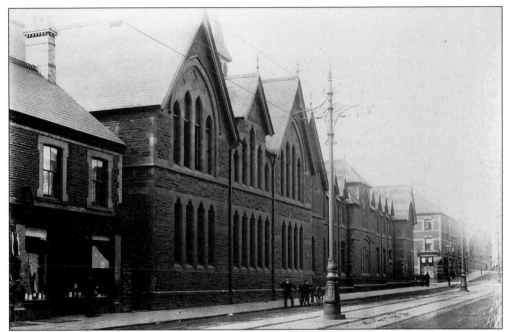

Splotlands Board School in 1903. It was opened in July 1882 for 596 boys, 544 girls and 596 infants and was enlarged in 1896. It closed in 1965 and was demolished *c.* 1971. In October 1976 South Glamorgan County Council, owners of the land, agreed that this should be the site for the new Star Centre which was opened on 18 July 1981.

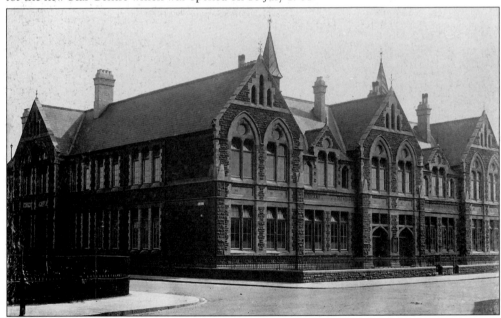

Moorland Road School, 1903. It was opened on 14 January 1891 and enlarged in 1894-5. 117 children were enrolled after one week, the first head teacher recording that upon examination the children proved to be extremely backward in their work. The school was damaged by enemy action on 3-4 March 1941, and for a time the pupils were split between Splotlands School, Jerusalem Vestry and East Moors Hall.

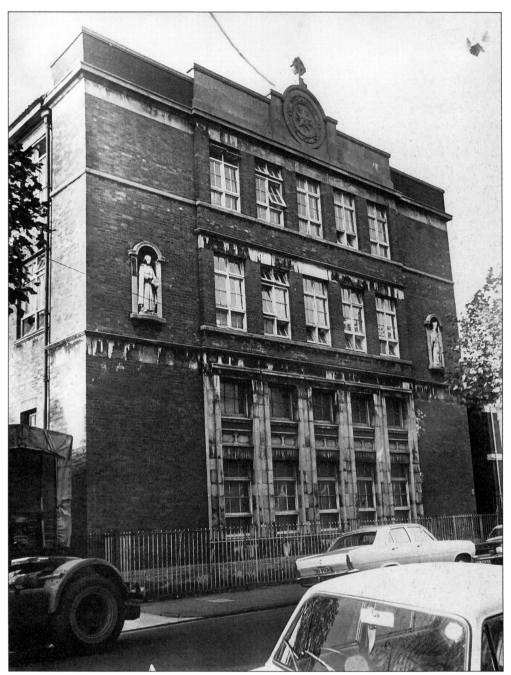

St Illtyd's College extension (c. 1937), Courtenay Road, 1971. The building dates from 1906 when it became the permanent home of the Splott University Settlement (founded in 1901 at Nos 50 and 52 Portmanmoor Road). Like similar settlements elsewhere its aim was to promote education and recreation for the people of poor urban districts. S.U.S. had a famous baseball team which drew crowds of up to 20,000. In 1924 the settlement became St Illtyd's College, the first Catholic grammar school in Wales. After St Illtyd's moved to Llanrumney in 1964 the building subsequently became a printing works.

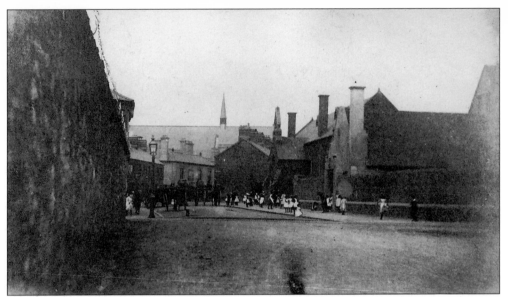

St German's National School on Metal Street, *c.* 1890. It was built in 1874 on a site close to Christ Church which itself was converted into an infants' school. The new school was officially opened on 3 July 1875. It cost £3,400 and was designed by G.F. Bodley, who later designed St German's Church. The school closed in July 1983 and is today occupied by St German's Court and St German's Mews. In the background is St German's Church and the Great Eastern Hotel.

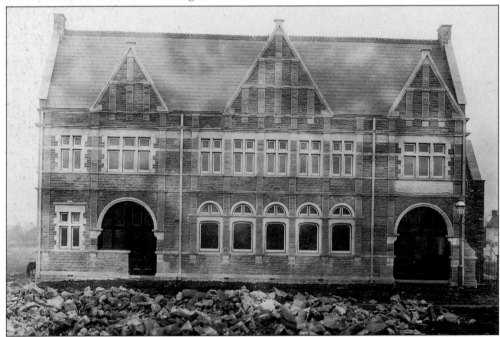

Albany Road Baptist School, 1898. Albany Road Baptist Church (formed 23 May 1894) started life as the Cottrell Road Baptist Mission in July 1893. In March 1895 planning for a school chapel began. The latter opened on 2 March 1898 and stood next to Ty-y-cwn Cottage which it owned and which was demolished the following May, (see page 26). The site of the cottage is today occupied by Albany Road Baptist Church, opened on 14 December 1932.

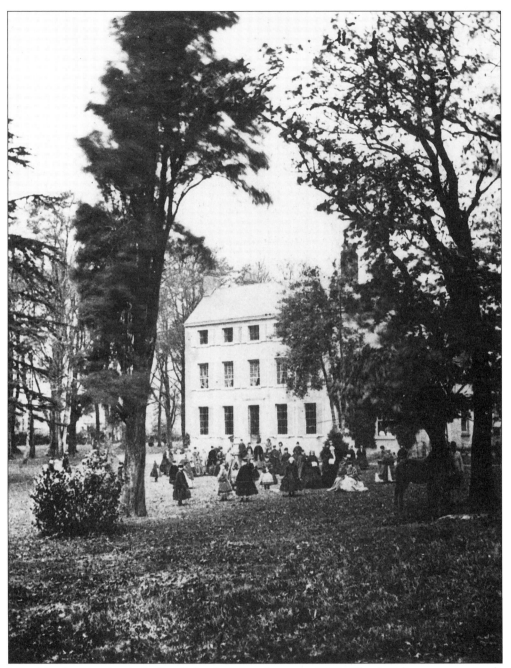

Miss Martha Vaughan's Ladies School, Adamsdown, *c*. 1870. The building was previously Adamsdown House, occupied in the mid-nineteenth century by Whitlock Nicholl, a member of an illustrious Glamorgan family, and earlier by Henry Hollier, chief agent to the Marquess of Bute. Miss Vaughan had previously run a boarding school at 49 Crockherbtown. Adamsdown House was demolished *c*. 1875 and is now the site of Adamsdown Square.

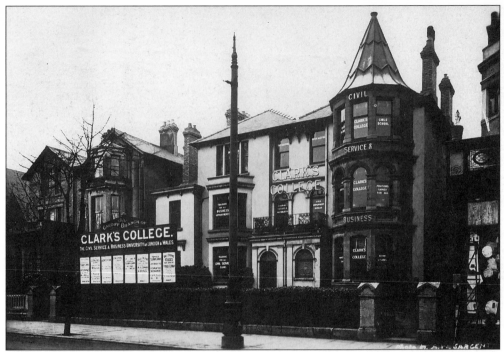

Clark's College, Newport Road, *c*. 1913. It trained many for careers in the civil service, business and commerce. It closed in July 1976 and was demolished in 1981 as part of the Longcross Court development. No. 49 Newport Road was previously known as 'Normandie' and was the residence of Emile Andrews who let it to Clark's College in 1911.

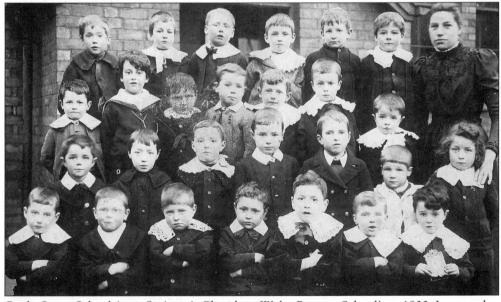

Crofts Street School (now St Anne's Church in Wales Primary School), *c*. 1900. It opened *c*. 1879 and was originally a school chapel known as St Clement's in Crofts Street (opened 1 August 1875). In 1887 St Clement's was replaced by St Anne's Church on an adjacent site, with a church school alongside.

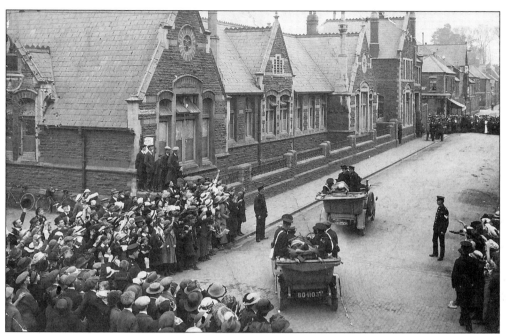

Albany Road School was used as a military hospital during the First World War. The school log for 24 August 1914 reads "School re-opened but had been taken over by the War Office as a Military Hospital – children sent to Roath Park and Marlborough [schools]...." *Above* and *below* crowds gather to greet the arrival of wounded soldiers at the Plasnewydd Street entrance, *c.* 1915.

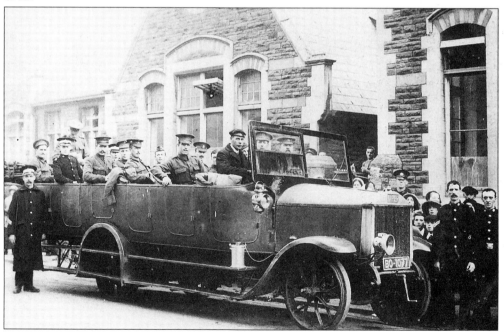

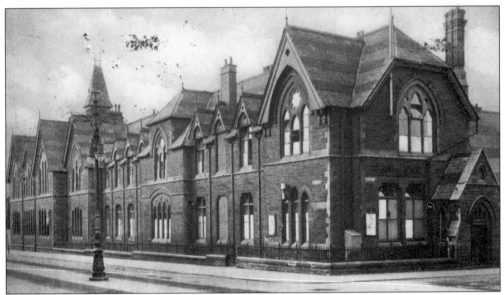

Splott Road Military Hospital, 1915. Like Albany Road, Splotlands School was commandeered for use as a hospital during the First World War, the children and teachers sharing Moorland Road School on a half day basis.

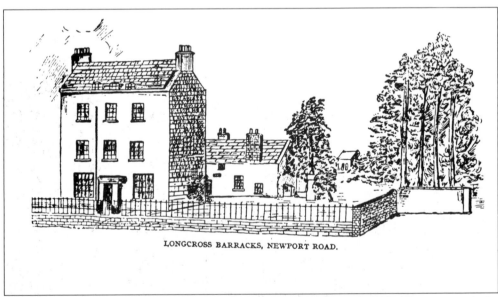

LONGCROSS BARRACKS, NEWPORT ROAD.

Longcross Barracks, Newport Road. It was the Chartist rising of 1839 that prompted the building of the Barracks, Longcross House being demolished c. 1844 for this purpose. On census night 1851, 103 persons were at the barracks, 82 of whom were soldiers, mostly Irish. Although fully occupied in 1871 the only persons there in 1861 were three Chelsea pensioners! It was demolished in 1880, the site then being occupied by the Glamorgan and Monmouthshire Infirmary and Dispensary.

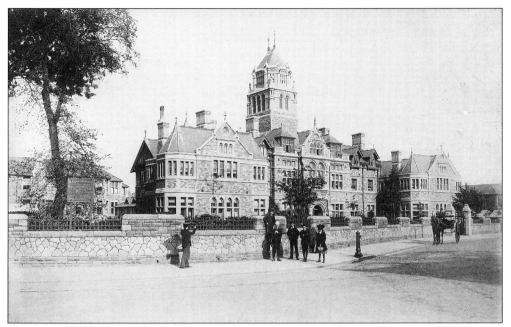

The Cardiff Infirmary, *c.* 1900. Completed in 1883 at a cost of £23,000, the Glamorgan and Monmouthshire Infirmary and Dispensary was originally opened in 1837 in another part of Newport Road. It was renamed the Cardiff Infirmary in 1895, the King Edward VII Hospital in 1911 and, from 1923, the Cardiff Royal Infirmary. Its future is uncertain as there are plans to transfer the Accident and Emergency services to the University Hospital of Wales Healthcare N.H.S. Trust at the Heath and redevelop the C.R.I. site as a community hospital.

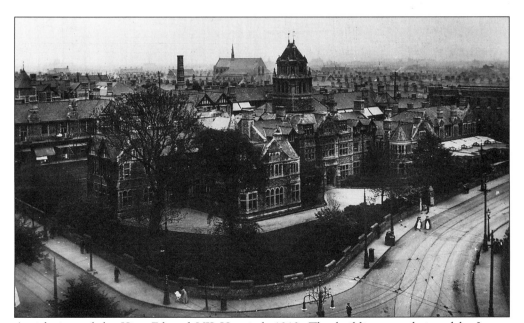

Aerial view of the King Edward VII Hospital, 1913. The building was designed by James, Seward & Thomas, but the chapel, erected on the site of the trees and designed by E.M. Bruce Vaughan, was not built until 1921. St German's Church is prominent in the background.

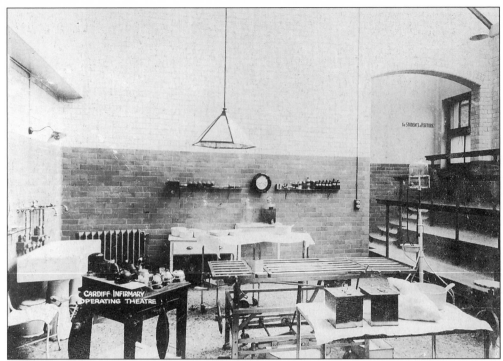

Operating theatre, Cardiff Infirmary, 1906. The writer of the postcard describes it as the "Slaughter House" and a "horrible sight". Only the small operating table is to be seen. The student gallery is on the right.

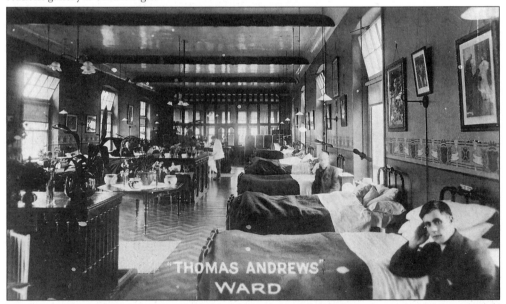

Thomas Andrews Ward, 1908. The hospital was built entirely by voluntary subscription and the main wards were named after donors who gave £1,000 or more. This one was named after Thomas Andrews, a prominent local councillor, mayor, and J.P. who did much to relieve the Infirmary from debt. A native of Somerset, he was the pioneer of the Splott Free Library Movement.

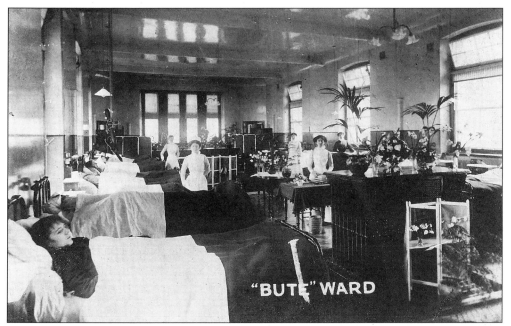

Bute Ward, 1908, named after John, the third Marquess of Bute (1847-1900).

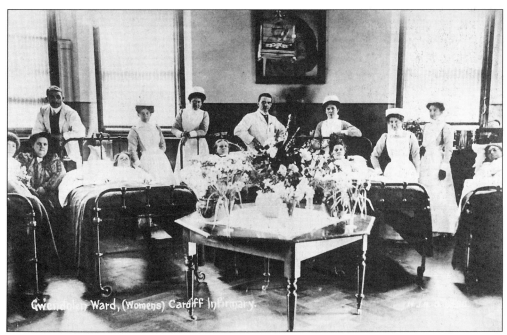

Gwendoline (Women's) Ward, c. 1908. It was named after Gwendoline (d.1932), the Marchioness of Bute, and wife of the third Marquess. She was born Gwendoline Fitzalan-Howard and her father was the first Baron Howard of Glossop. A plan of the 'new street' that became Glossop Road is dated 1876.

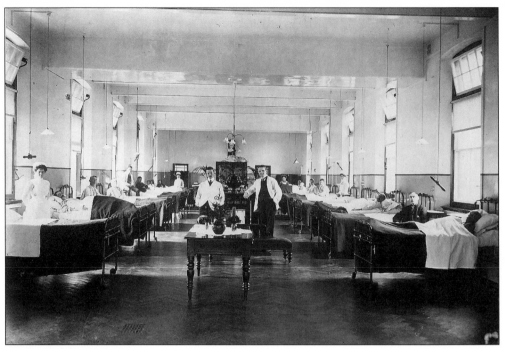

Insole Ward, c. 1910. It was named after James Harvey Insole (born c. 1820), colliery proprietor, of Ely Court, Llandaff (later named Llandaff Court).

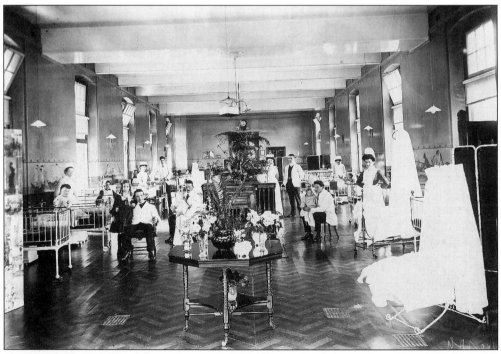

Shand (Children's) Ward, c. 1910. It was named after Miss Frances Batty Shand (1810-1885) the founder, in 1865, of the Association for the Improvement of the Social and Living Conditions of the Blind, the precursor of the Cardiff Institute for the Blind (Shand House).

Seven

Streets

The population of Roath stood at 312 in 1851 and rose as follows: 3,044 (1861), 7,791 (1871), 23,096 (1881), 39,657 (1891) and 61,074 in 1901 by which time the district had been transformed from an agricultural area to a mature suburb. Whereas in 1851 the principal thoroughfares were Roath (Newport) Road, Green Lane (Broadway), Crwys Road, Heol y Plwcca (City Road), Merthyr (Albany) Road and Welshman's Hill (Penylan Road), by 1914 some 260 new streets had been constructed or were planned. The process began in the 1850s, reached its zenith in the 1880s and 1890s and has proceeded slowly, though remorselessly, to the present day.

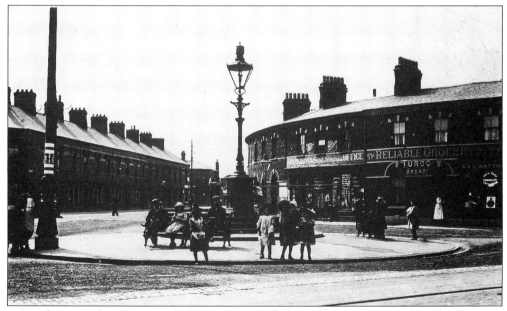

Adamsdown, at the junction of Meteor Street and Constellation Street, 1909. This area was known as Moira Crescent in 1880. The parish boundary ran the length of Meteor Street, a pre-1861 thoroughfare.

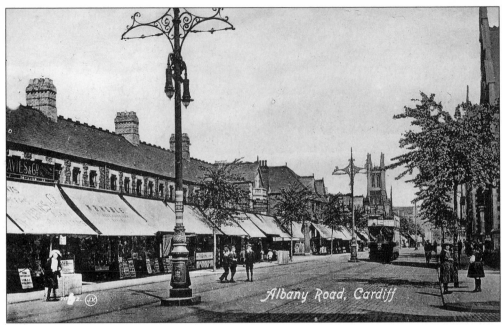

Albany Road, Cardiff

Two views of Albany Road, c. 1910. It was named in memory of the Duke of Albany, the youngest son of Queen Victoria who died at Cannes on 28 March 1884. Hitherto, it had been known as Merthyr Road, which had been constructed as a result of the Heath Enclosure Act of 1801, and followed the course of a public drain! Plans for the first nine houses were approved in February 1884 at the junction with Mackintosh Place. Conversion of the ground floors into shops started in 1893 and had virtually reached saturation point in 1914, by which time 117 shop front plans had been authorised. This part of Albany Road bisected the Mackintosh estate and represented the principal commercial thoroughfare in the district.

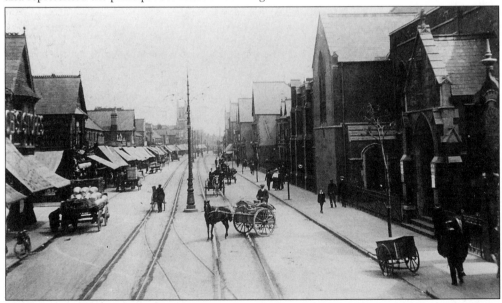

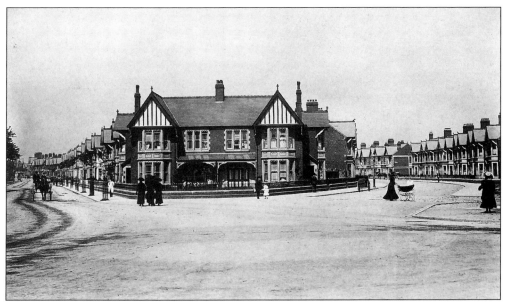

Albany Road and Marlborough Road, 1910. Marlborough Road ran through Tir Colly farmland, part of the Ty Mawr estate owned by Lord Tredegar. His exploits at Balaclava during the Crimean War seem to have inspired his agents to create a virtual 'battlefield' of street names in this area, commemorating British victories abroad. The first house plans for Marlborough Road date from 1898, while this part of Albany Road, dating from 1906, has always been residential, and is in fact the reconstituted old village street.

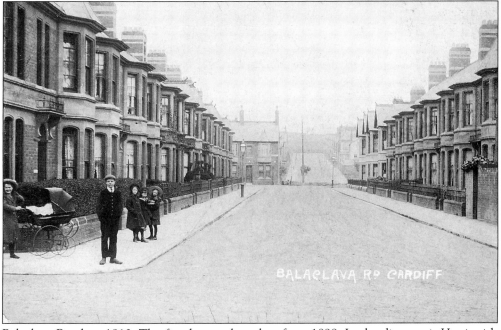

Balaclava Road, c. 1910. The first house plans date from 1898. In the distance is Harrismith Road, the first house plans for which date from 1904.

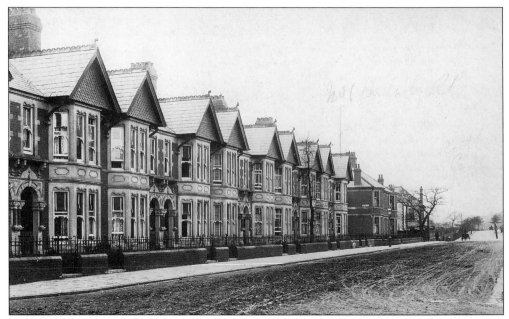

Kimberley Road, *c.* 1910. This was built on an outlying portion of Pengam Farm cutting through, in part, Ty y Cyw land. The first house plans date from 1904. Ty Draw Road lies in the distance.

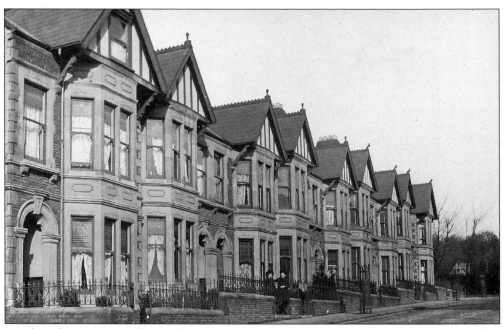

Penylan Place, *c.* 1910. This was built on Waun Isha (1840), part of Penylan Farm owned by the Bute estate. The first house plans date from 1903.

Ty Gwyn Road, *c*. 1900, which covered part of Penylan Farm, alias Ty Gwyn. The first house plans date from 1890.

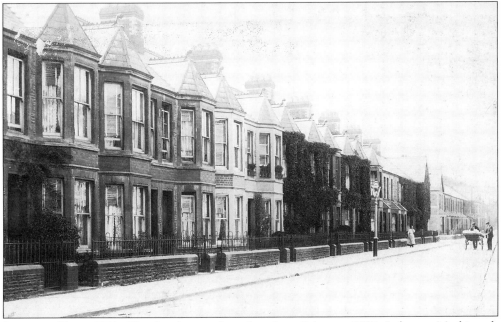

Inverness Place, 1911. The first house plans date from February 1884. It lay on Mackintosh estate land cutting through Ty yn y Coed farmland (the farm was demolished in 1895). Tyn y Coed Place can be seen in the distance.

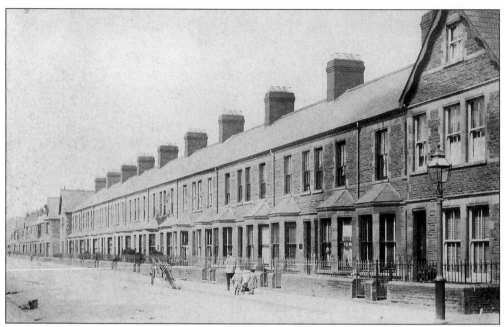

Arabella Street, c. 1910. Constructed on Ty yn y Coed farmland, the first house plans for this street date from 1884. Like Diana Street it takes its name from Harriet Diana Arabella Richards, the heiress to the Plasnewydd estate, who married Alfred Donald Mackintosh (the Mackintosh of Mackintosh). His names are also commemorated in the streets of this part of Roath.

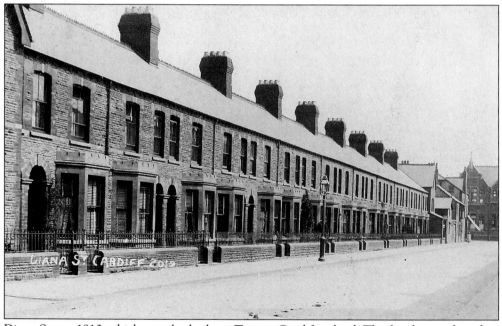

Diana Street, 1910, which was also built on Ty yn y Coed farmland. The first house plans date from October 1891. Albany Road Board School can be seen in the distance.

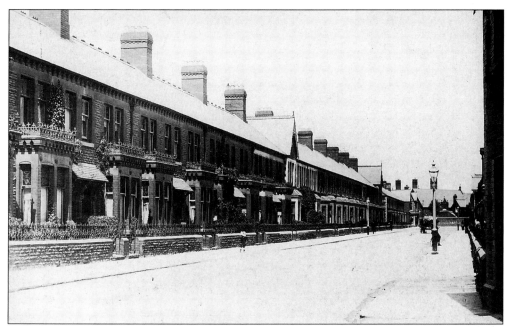

Alfred Street, c. 1910. It, too, cut through Ty yn y Coed farmland. The street followed the boundary between the Mackintosh and Bute estates for part of its length. Roath Park School lies in the distance, built on Penywain farmland (Bute land).

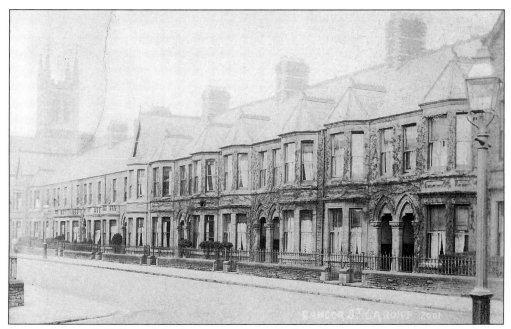

Bangor Street, 1910. Part of the Bute estate, it was built on Penywain land with the first house plans dating from 1891. Roath Park Wesleyan Methodist Church can be seen in the distance.

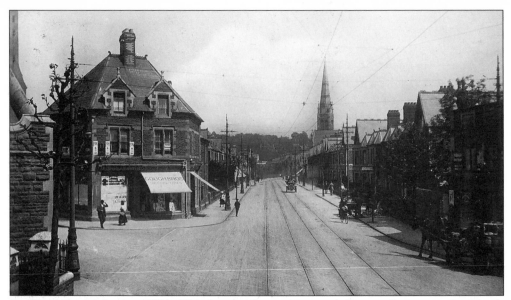

Wellfield Road, *above*, *c*. 1911. The shop at the junction with Bangor Street is today Lloyds Bank. The picture *below* dates from 1950. Note the trolley bus cables. The road cut through Cae Ty Coch, part of Penywain Farm, and was constructed in 1891, the date of the first house plans. It lay on Bute land and provided a short cut from Albany Road to Roath Park, which was officially opened on 20 June 1894. By 1914 many of the houses had been converted into commercial premises.

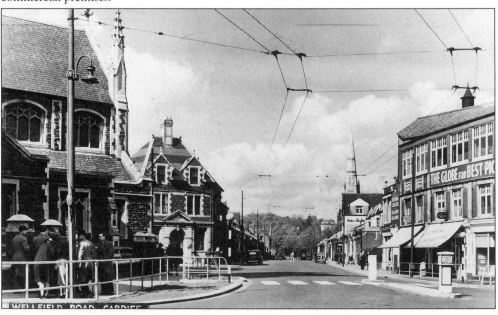

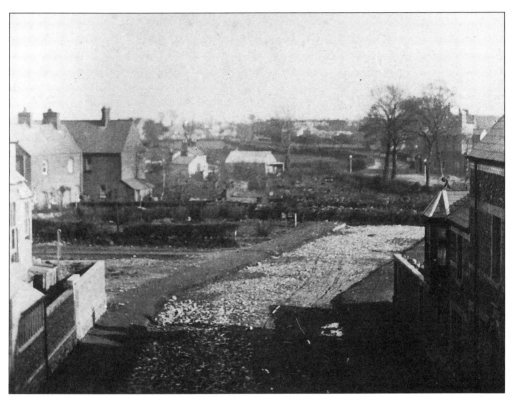

Wellfield Place under construction, 1894. Built on Bute land, the large houses to the left are Delta Place which was demolished in 1899; in the centre is an outbuilding of Cross Cottage which lies behind, and to the right is the Roath Park Refreshment Room. Ty-y-cwn lies behind this. With the construction of Wellfield Place the remnants of a hamlet here were obliterated.

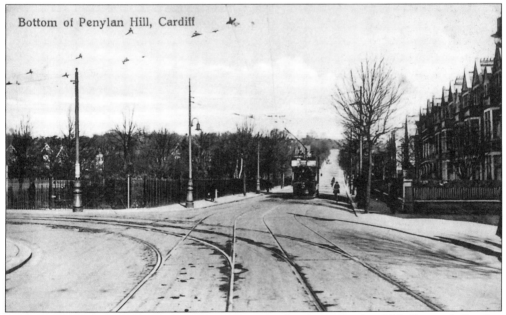

Bottom of Penylan Road, c. 1905, at the junction with Ninian Road and Marlborough Road.

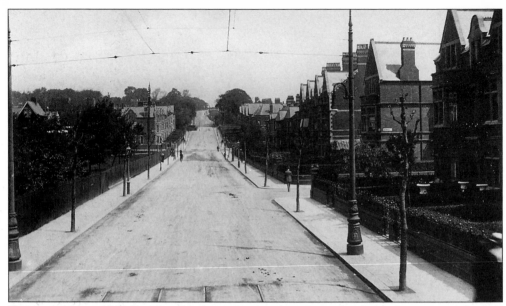

Penylan Road, *c.* 1910. Penylan Road is an 'ancient' trackway that led to Lisvane and the 'hill country' and is shown on George Yates's map of Glamorgan in 1799. It would seem to equate with 'Walshmenhull' (Welshman's Hill) which appears in a minister's account of 1392, and which may have connected Roath Court with Lisvane (Llysfaen = stone court) in pre-Norman times. The first house plans for Penylan Road date from 1865.

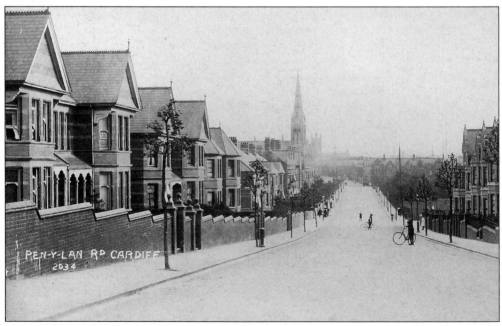

Penylan Road, *c.* 1910, looking south. The Roath Park Presbyterian Church dominates the skyline.

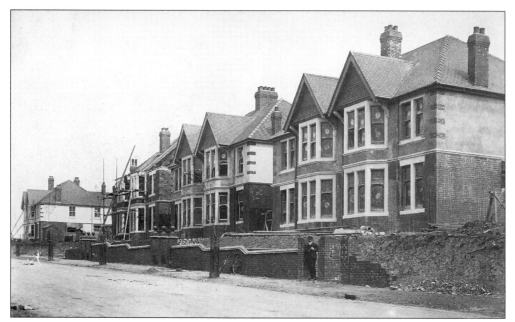

Penylan, 1912, showing houses on Cyncoed Road in the course of construction. The first house plans date from July 1910. The land had formed part of the Lower Llwyn y Grant Farm (165 acres), owned in 1840 by Thomas William Edwards, having been sold by the second Marquess of Bute in 1835.

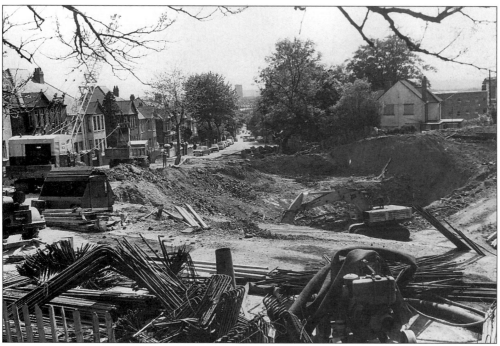

Roadworks at the junction of Penylan Road and Cyncoed Road in connection with the Eastern Avenue bypass, June 1970. The bypass was opened in 1971.

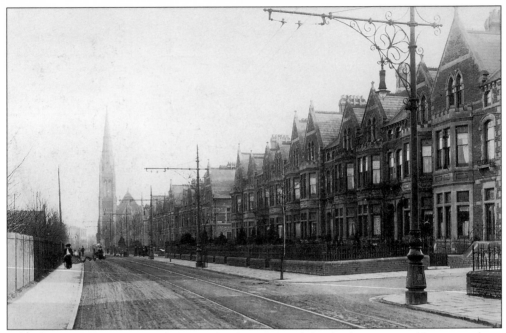

Ninian Road, 1908. It was named after the second son of the third Marquess of Bute, on whose land it lay (Penywain Farm). The first house plans date from 1891.

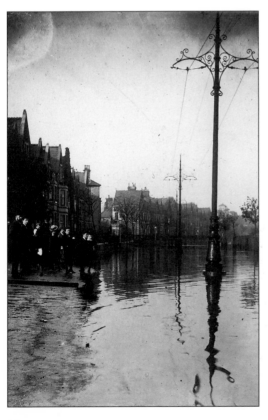

Floods at Roath, Ninian Road, 1893.

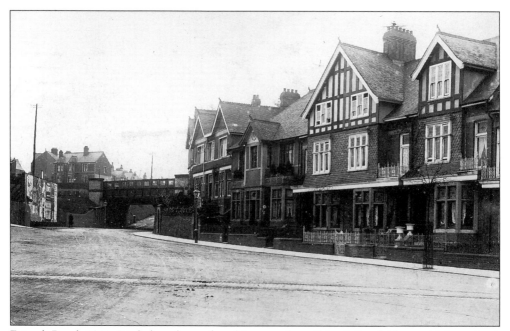

Fairoak Road, 1909. Little has changed at this spot where Fairoak Road (the parish boundary) meets Shirley Road and Ninian Road. The first house plans date from 1896. Fairoak Farm lay nearby, where the Eastern Avenue bypass now runs, athough it was in Llanishen parish.

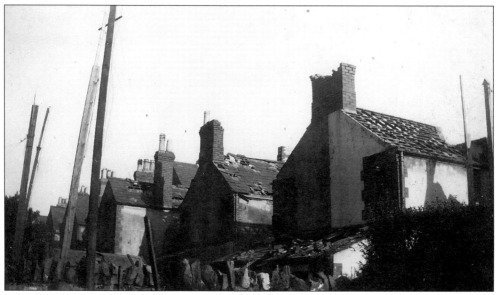

Bomb damage at Angus Street after a raid on 3 September 1940. The bomb landed on the wall between Nos 91 and 93 Albany Road. All of the shops in that block lost their windows, but the main force of the blast went towards Angus Street where people were killed. Houses on both sides of the street had to be rebuilt.

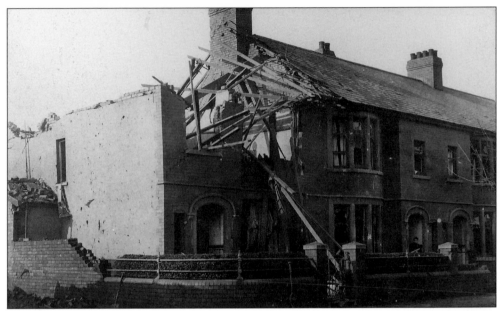

No. 106 Roath Court Road after a raid on 2 January 1941. Several properties at the Roath Court junction with Newport Road sustained serious damage.

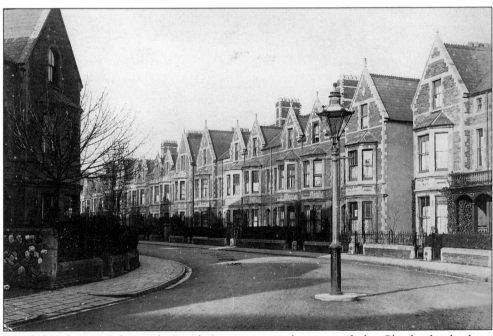

Claude Road, 1908. It lay on the Roath Court estate and was named after Claude, the third son of Charles Henry Williams. The first house plans date from 1886.

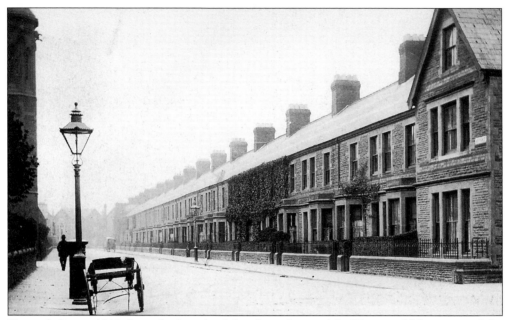

Keppoch Street, 1911. It was built on land that formed part of the Plasnewydd demesne and the first house plans date from 1886. Plasnewydd Presbyterian Church stands on the left.

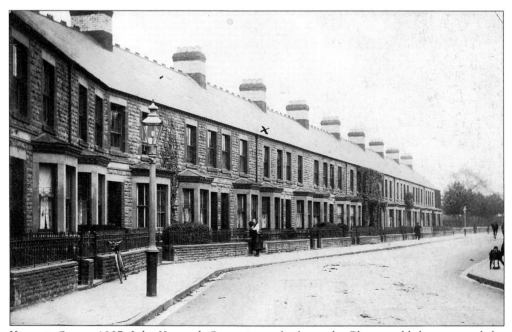

Kincraig Street, 1907. Like Keppoch Street it was built on the Plasnewydd demesne and the first house plans also date from 1886. The grounds of the Mackintosh Institute can be seen in the background.

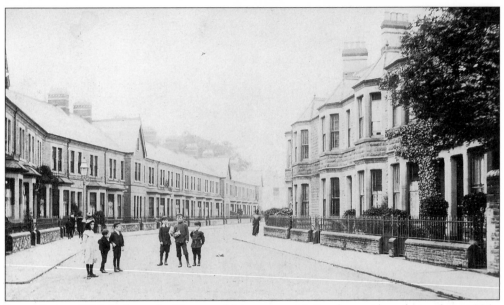

Arran Street, 1910, built on the Plasnewydd demesne with first house plans dating from 1886.

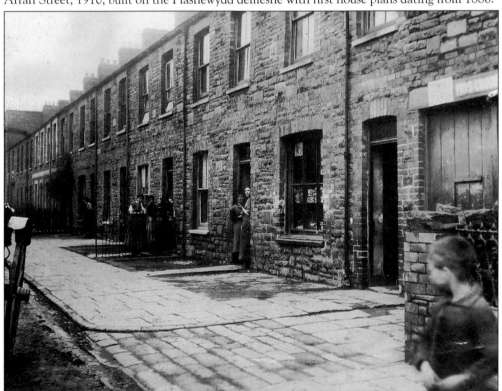

Russell Street, c. 1900. A request in 1919 to rename it "Patriots Avenue" in memory of those who died in the First World War was refused by the Council, who felt such a name could be connected with the 1916 EasterRising as there was a large Irish population in the area. A plaque commemorating 'The Heroes of "Patriots Avenue" (known as Russell Street)' was unveiled on V.E. Day 1995.

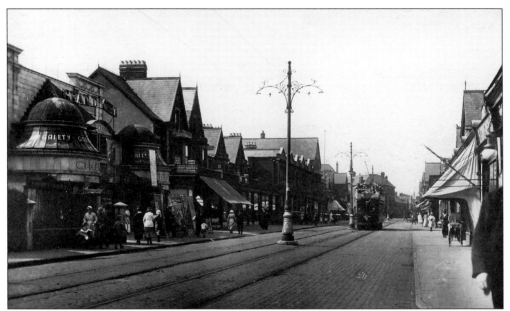

City Road, *above*, *c*. 1914, showing the Gaiety Cinema built in 1912 (it became a bingo hall *c*. 1960), and, *below*, in the distance, the Royal George Hotel (built in 1888), *c*. 1900. The landlord in 1891 was Samuel Loveless of Tolpuddle, Dorset, no doubt a descendant of George and James Loveless, two of the Tolpuddle Martyrs. Plwcca Halog also stood here – the 'unhallowed plot' or 'Gallows plot' and the site of the town gibbet.

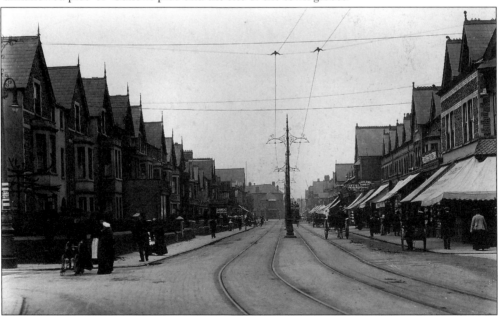

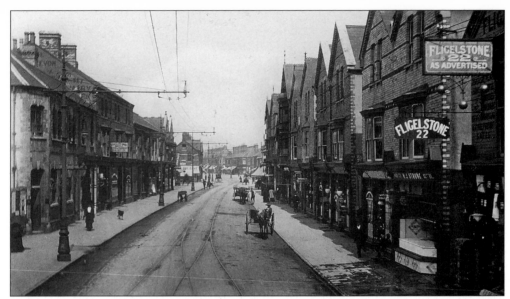

City Road, *c.* 1920, showing Fligelstone's, the jewellers. Along with Crwys Road, City Road formed part of the western boundary of the parish. It was previously known as Heol y plwcca (Plwcca Lane), and from 1874 as Castle Road, on account of Roath Castle, as Plasnewydd had been ostentatiously styled. It was renamed City Road in 1905 when Cardiff was elevated to this status. It follows an 'ancient' roadway and the first house plans date from 1873.

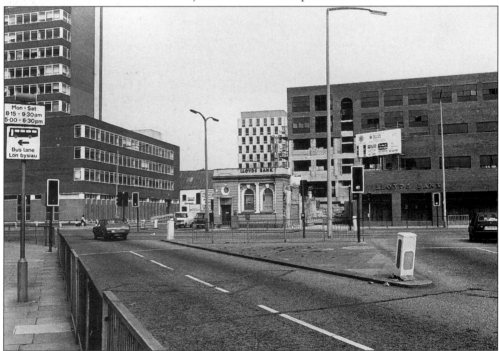

City Road at its junction with Newport Road, 6 June 1982, showing Lloyds Bank undergoing demolition. Longcross Court, opened in 1982, stands on what was known in 1840 as Longcross Field. The 'Longcross' was, like 'Crwys Bychan' at the junction of Crwys Road and Fairoak Road, a boundary cross for the medieval borough of Cardiff.

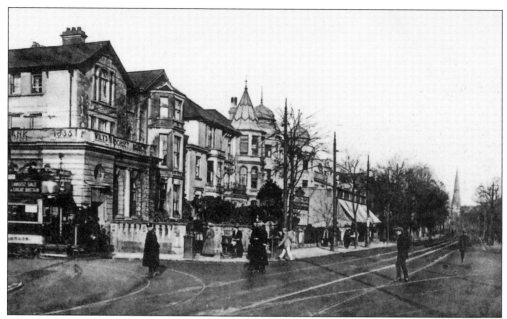

Newport Road at the junction of City Road, *c.* 1914. The Wiltshire and Dorset Bank, at No. 45 Newport Road, here from at least 1894, became Lloyds Bank in 1918. No. 47 was for some years the home of Solomon Andrews, businessman and entrepreneur. No. 49, with the conical tower, is Clark's College. Newport Road (formerly Roath Road) is an 'ancient' highway. The first villas were built here in the 1850s, many of which were demolished in the late 1970s.

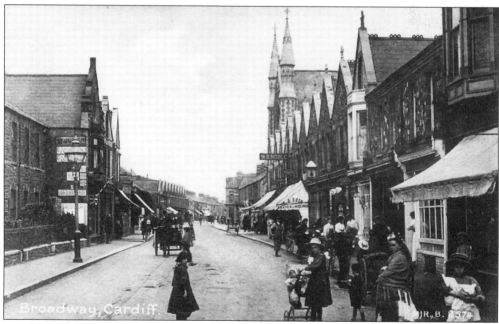

Broadway, *c.* 1912. Another 'ancient' highway, known until 1875 as Green Lane. The first house plans date from 1867.

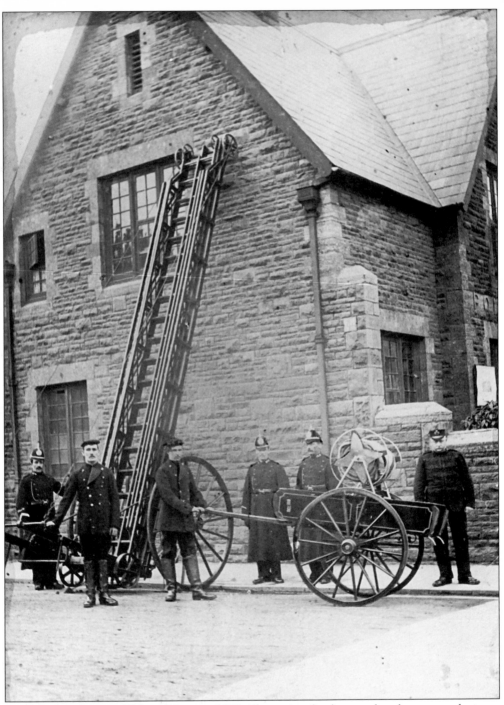

Roath Police Station, Clifton Street, c. 1890, illustrating fire hose reel and escape techniques for use at fires while awaiting the arrival of fire engines from Cardiff. At the station in 1891 were William Cox (Inspector), his wife and son, one servant, and five police constables (all boarders).

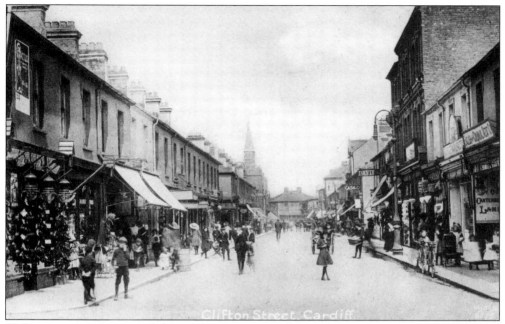

Clifton Street, 1909. One of the principal commercial thoroughfares in Roath, it was formerly known as Connection Street changing its name to Clifton Street on 5 May 1868. The first house plans date from 1866.

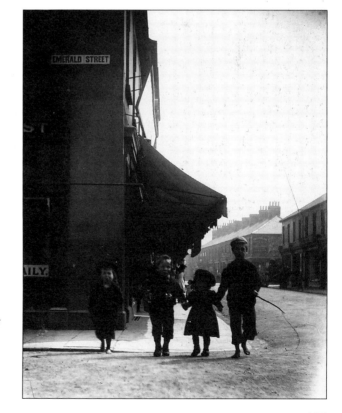

Clifton Street at its junction with Emerald Street, c. 1900. The first house plans for the latter date from 1874 and were built on Upper Splott farmland (Tredegar Park estate). One cannot help wondering whether Lord Tredegar's agents, in searching for new street names, looked to the minerals that lay beneath the earth and to the heavens above for inspiration!

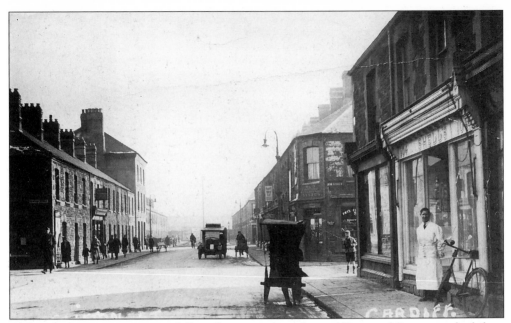

Clifton Street at its junction with Iron Street, on the right, and Diamond Street, on the left, c. 1910. The house plans for Iron and Diamond streets date from 1871, and both were built on Upper Splott farmland. The Tredegar public house (top left) dates from the 1870s.

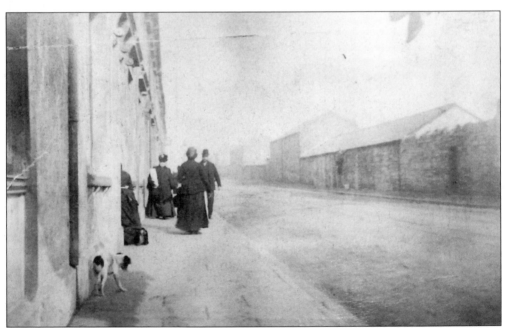

Constellation Street and Roath Market, 1891. Constellation Street is pre-1861, though the first house plans date from 1864. It straddles both the Adamsdown and Upper Splott farms, this part, and the market, falling on the latter.

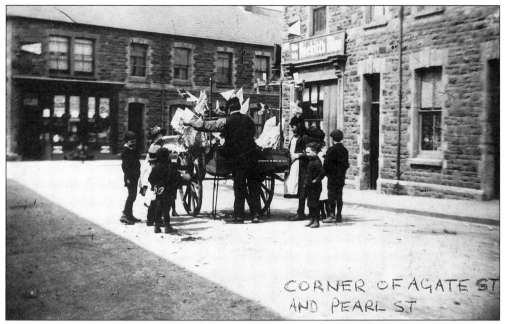

The corner of Agate Street and Pearl Street, 1891. Agate Street and this part of Pearl Street also fell on Upper Splott farmland. The first house plans for both date from 1874.

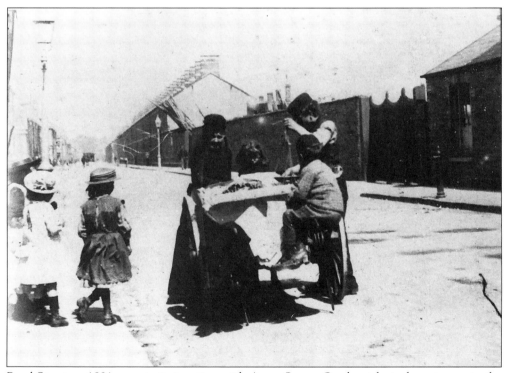

Pearl Street, c. 1891, near to its junction with Agate Street. On the right is the entrance to the Roath Railway Station (see page 144).

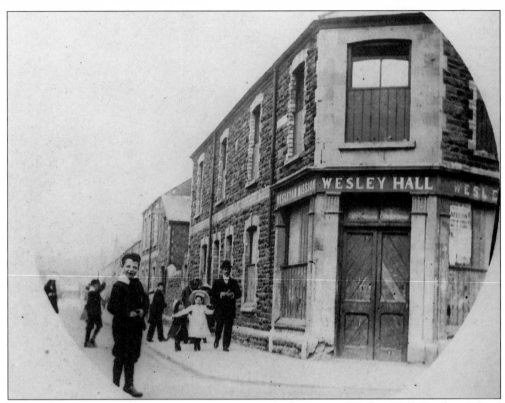

Harold Street and Pearl Street junction, *c.* 1916, showing a Wesley Hall Sunday School Whitsun treat. The teacher with the bowler hat is Mr Verdon. At the back in long trousers is Mr William Down of Angus Street. The first house plans for Harold Street date from 1875.

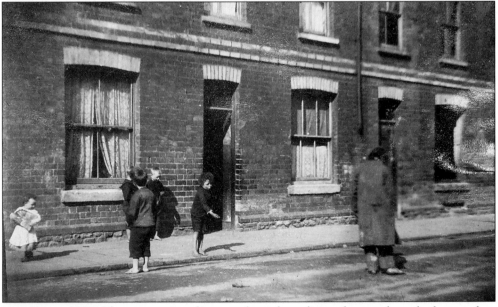

Nora Street, 1892. These evocative glimpses of social conditions here and overleaf were taken by W.H. Booth. Formerly known as John Street, it is pre-1861 in origin.

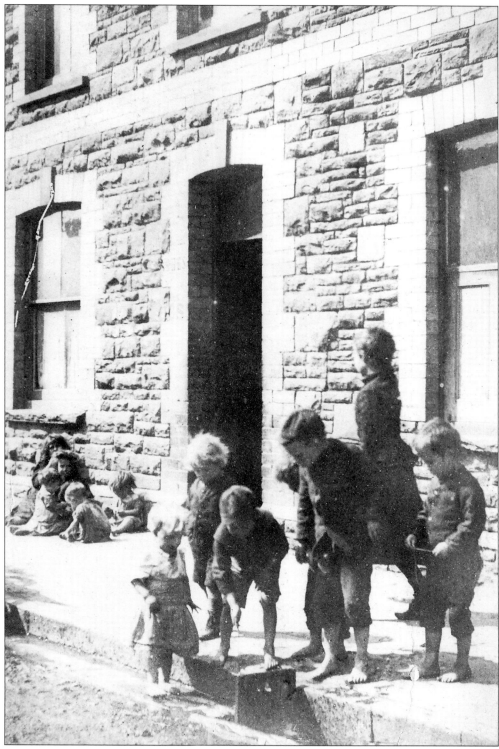

Nora Street, 1892.

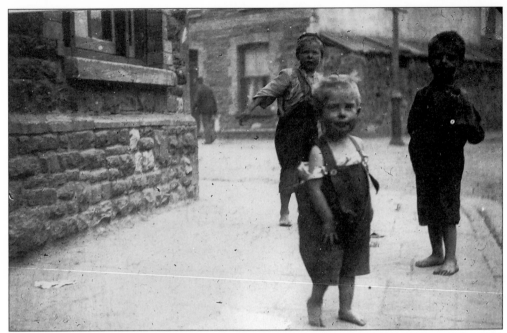

Helen Street, 1892. The first house plans date from 1866 with Nos 1-12 appearing on the 1871 census. A further 74 were planned in 1885. All the streets with Christian names in this area were part of William Bradley's estate. In 1840 it was known as Endless Farm.

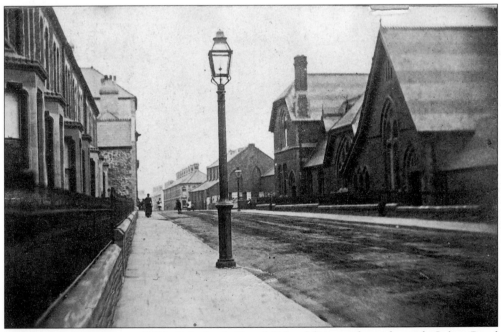

Railway Street, Splott, *c.* 1890. Splotlands Board School lies on the right with Splott Road Baptist Church schoolroom beyond. The first house plans date from 1881.

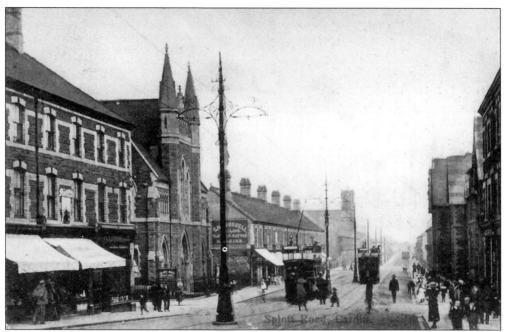

Two 1905 views of Splott Road, the main commercial thoroughfare in this district. The first house plans date from 1886 when fifteen were submitted by the Tredegar Park estate architects Habershon & Fawckner. Plans for 12 shops were also put forward in this year. The plan for Splotlands Board School was submitted in March 1881.

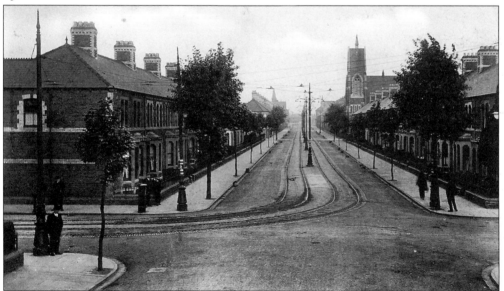

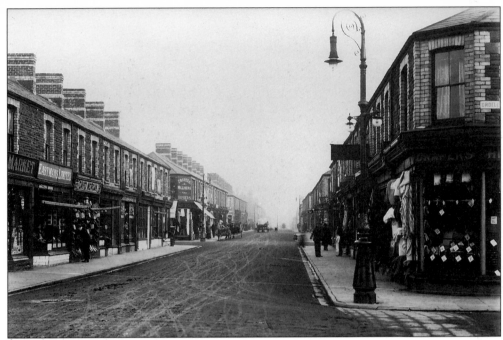

Carlisle Street at its junction with Ordell Street, *c.* 1910. The house plans for both date from 1881. The architects were Habershon & Fawckner.

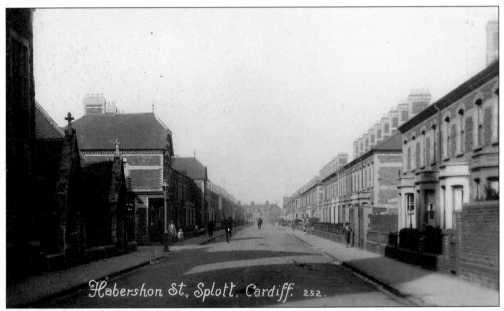

Habershon Street, *c.* 1925. Little has changed in this street, which was named after William Gillbee Habershon, principal architect to the Tredegar Park estate. The first house plans date from 1883.

Two views of Portmanmoor Road, *c.* 1975. Near here stood some of the Dowlais Cottages which were the first dwellings to be built in Splott after the Dowlais Ironworks was opened.

Plans were submitted by the Dowlais Iron Company in 1890 and, by 1892, 126 houses had been completed at a cost of £14,175, with work in progress on a further 85 in Portmanmoor Road, Swansea Street and Cornelia Street. Although the first house plans date from 1887 this is a medieval thoroughfare mentioned in an inquisition post mortem of 1440.

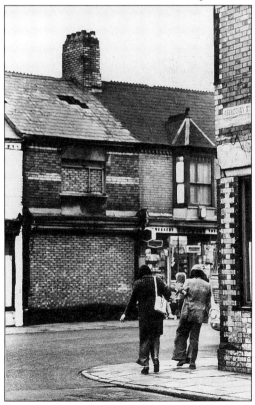

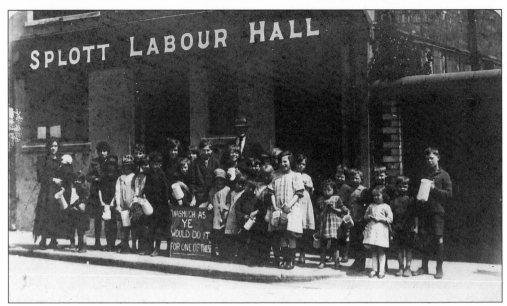

Splott Labour Hall, Neath Street, in the 1930s, showing children with jugs ready for soup.

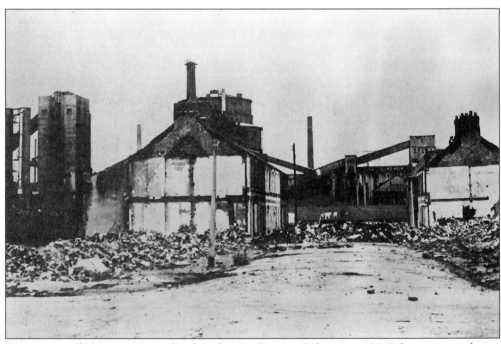

Destruction of a community – the demolition of Lower Splott, c. 1978. Fifteen streets dating from the late 1880s and 1890s were demolished between 1972 and 1978: Menelaus, Layard, Enid, Elaine, Cornelia, Greenhill, Robinson Square, Smith, Bridgend, Caerphilly, Llanelly, Pontypridd, Wimborne, Tenby and Milford. Most of Neath Street, Swansea Street, Singleton Road and Portmanmoor Road, including the Dowlais Cottages, also went. Only Aberystwith, Aberdovey and Hinton Streets survived virtually intact.

Eight

Shops

Suburbanisation spawned commerce. Merthyr Road, renamed Albany Road in 1884, became, within a few years, the principal commercial thoroughfare in the district. Similarly, City Road, Crwys Road, Wellfield Road, Clifton Street, Broadway and Splott Road had also developed thriving commercial sectors by 1914. All manner of trades and businesses existed as the extract from the trade directory on page 128 shows.

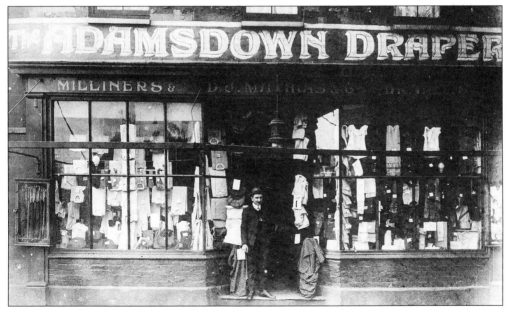

Adamsdown Drapers, early 1900s. D.J. Mathias & Co. were in business at No. 13 Moira Place from 1907 until the mid-1960s. The premises is today a convenience store and newsagents.

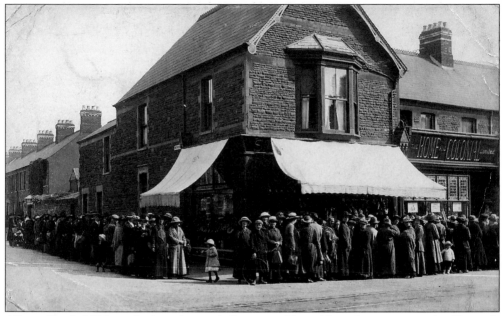

Albany Road, 1914, at the junction with Inverness Place. Note the queues at the Home & Colonial Stores (No. 13 Albany Road) caused by wartime rationing. Stead & Simpson (No. 11) is under the canopy. The site was later occupied by H. Collins, draper and milliner. It is Tesco's today.

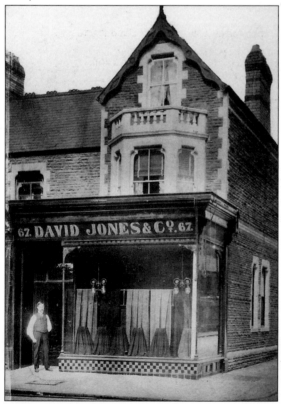

David Jones & Co., tailor at 67 Albany Road on the junction with Diana Street, 1911. Later the site was part of the Cardiff Co-operative Society Ltd, then Littlewoods and today Kwik Save.

A 1921 advertisement. Henry Collins established his grocery store at the junction of Albany Road with Cottrell Road at the turn of the century, having previously been in business in Diamond Street and Clifton Street. The business was carried on by his son and grandson, finally closing in late 1994. Marsh Umbrellas remained at Arabella Street until *c.* 1970.

119

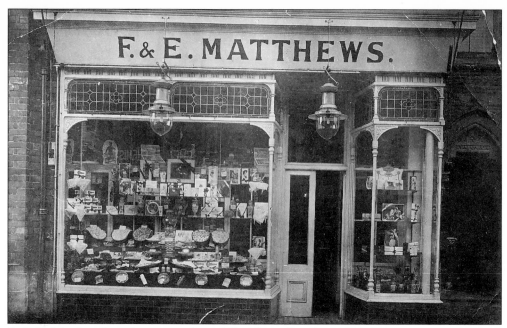

F. & E. Matthews' confectionery shop, 113 Albany Road, *c.* 1920. The premises were later occupied by the antiquarian bookseller, John Barrett (Albany Books). It was demolished in 1985 as part of the Globe Centre development.

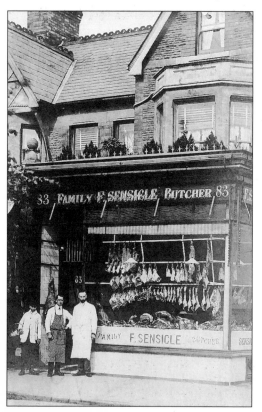

F. Sensicle, butcher's, which was in business from 1898 until 1920 at 113 Albany Road on the junction with Alfred Street. Later occupants of the site included Chain Libraries Ltd and Waterlow, newsagents. Today it is a branch of Superdrug.

Groceries of Quality.

WITH us Good Quality and Economy go hand-in-hand. We stock no goods that are not of thoroughly good and reliable quality, and we sell them at the very lowest market prices. You can always trust our goods. A trial order will convince you.

Argyll Stores (Cardiff), Ltd.,

City Road and Penywain Road, Cardiff.

J. W. HICKS,

English Meat Purveyor,

59, ALBANY ROAD, Roath, Cardiff.

Best English Meat, Pickled Beef, and Ox Tongues Sold.

E. C. SLEET,

Practical Boot Maker and Repairer,

84, BROADWAY, ROATH, CARDIFF.

Work Called for and delivered to any part of the City.

BESPOKE ORDERS A SPECIALITY.

GOOD LEATHER AND WORKMANSHIP GUARANTEED

Advertisement, 1921. No. 59 Albany Road later became the site of W.H. Monks, butcher and subsequently Littlewoods. Granada T.V. Rentals are there today.

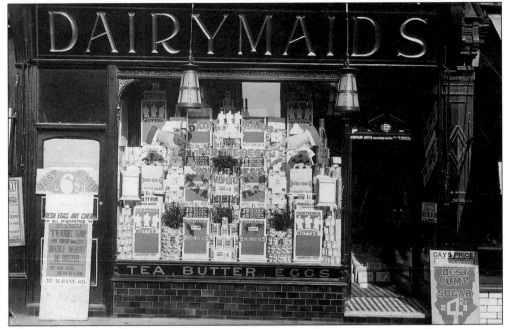

Dairymaids, 35 Albany Road, *c.* 1914. Stead & Simpson's has occupied the building since the mid-1920s.

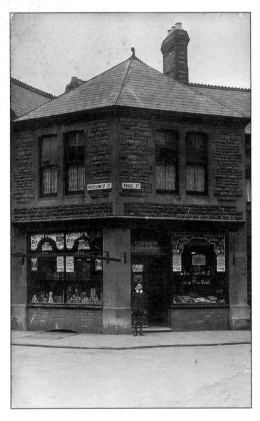

Charles Richards, grocer, 98 Angus Street, *c.* 1910, at the junction with Montgomery Street. William Williams, grocer was here later. It is currently a private residence.

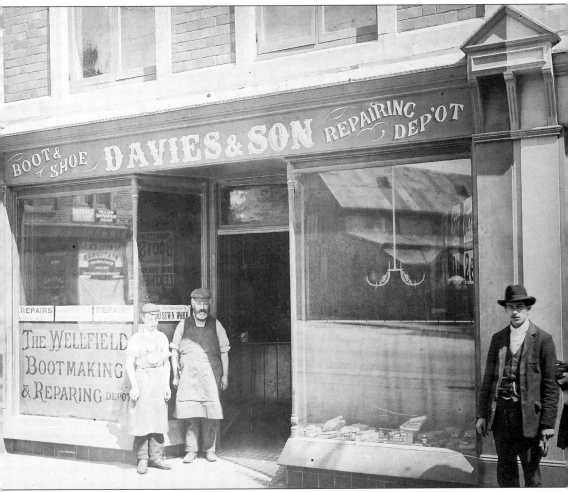

Davies & Son, boot and shoe repairing depot, c. 1902. The later 2c Wellfield Road occupied this site in front of the side of the Globe cinema. In 1900 it seems that the long side garden wall of 109 Albany Terrace was demolished and four lock-up shops of varying but shallow depth were built with two floors above. These were apparently undisturbed by the construction of the auditorium of the Globe cinema behind them in 1913. For many years they were collectively known as Albany Buildings and unnumbered. From about the 1920s they were known as Cinema Buildings and numbered 2(a), (b), (c) and (d) Wellfield Road. This shop is opposite the mouth of Bangor Street (Elliott's general shop and the original prefabricated Roath Park Wesleyan Methodist Church Hall, built 1893, are reflected in the window). The premises were latterly occupied by the Roath School of Motoring and were finally demolished in 1985 to make way for the Globe Centre complex.

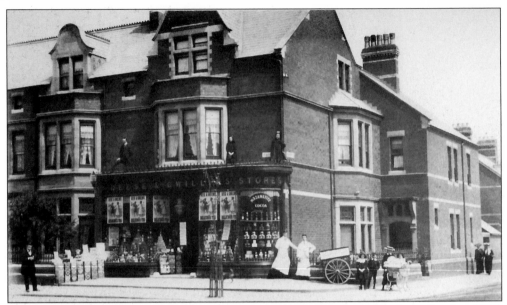

Reese & Gwillim's Stores on the corner of (No. 2) Penylan Road and Blenheim Road in 1905. They were there until the late 1960s. Flukes occupies the site today.

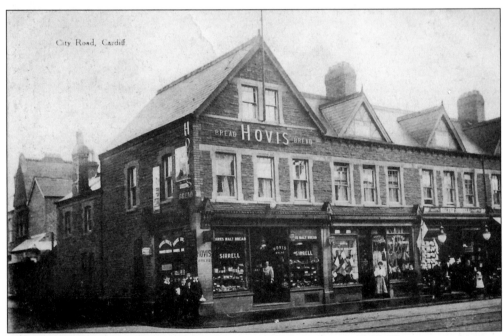

Sirrell's the bakers, City Road, at the junction with Pearson Street, 1910. They were in business for some thirty years until 1932 when Hunt's took over. The premises were later bought by Astey's. Today Martin Dawes Telecommunications occupies the site.

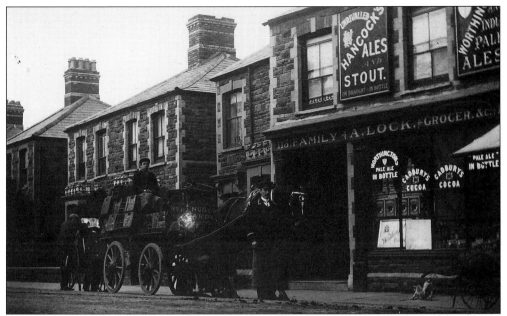

No. 113 Broadway, 1906, showing A. Lock, grocer and beer retailer, with a Hancock's dray arriving with supplies of beer. Hancock's ales enjoyed a great reputation in South Wales after 1894, and the famous drays became a familiar sight. In 1961 D.P.G. Bowen, beer retailer, was here. The building is now a private residence.

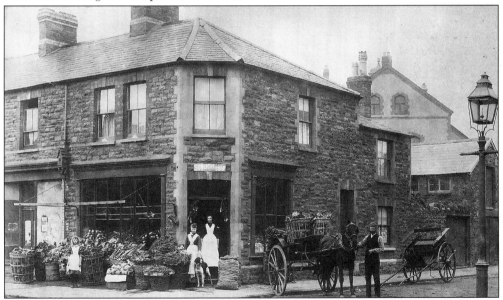

William Tovey's fruiterer and greengrocer's shop, 57 Broadway, *c.* 1887. In 1961 William Sellick, secondhand furniture dealer, was here. The Ideal Restaurant occupies the site today. The road to the right is now Richards Place, and the large building in the background was the newly built Stacey Road Hall, from *c.* 1894 home to the Stacey Road Congregational Church (disbanded 1916). It is today the Yamaha School of Music, having formerly been used as the Roath Electric Theatre, the Roath Public Hall, the Stacey Labour Hall and the Star Ballroom. It was also used for a time by the B.B.C.

Dowling's, Broadway, 1930s. Isaac and (later) Jacob Dowling's baker's and grocer's shop was at 167 Broadway by the junction with Fort Street. It dates from the late 1870s and lasted until the early 1950s. It is today Tools on Show, automotive tool and equipment specialists. Lilian King, an employee of Dowling's, won third prize in the window dressing competition depicted above, c. 1935.

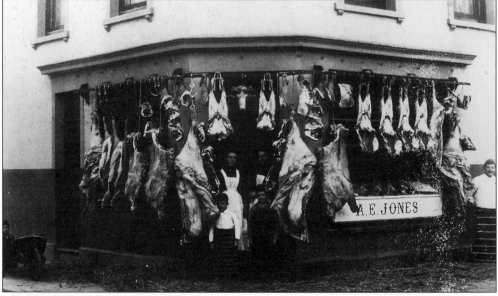

A.E. Jones, butcher, 57 Constellation Street, 1891. He was no longer trading there by 1899. The property was demolished c. 1980.

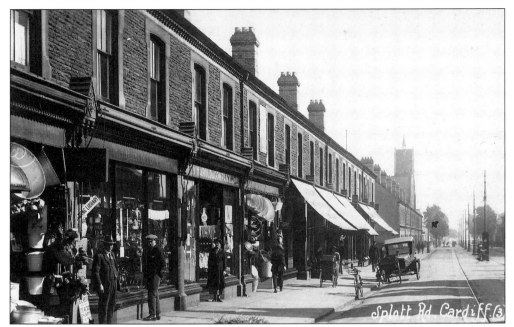

Splott Road, *c.* 1925, showing Harold & Company, outfitters and drapers, at No. 25, and other commercial properties between Railway Street and Carlisle Street.

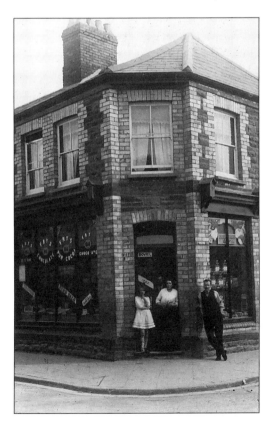

James Burrows' sweet shop on the corner of 59 Habershon Street and Marion Street, Splott, *c.* 1920. C.G. Morris, grocer, was here in 1961. The property is empty today.

SOUTH WILLIAM ST. *continued*
37 Binding James, diver
38 Thomas John, dockgateman
39 Merchant William
40 Pimm Charles, boatman
41 Sparks Wm., pier master
42 Eilertsen J., water clerk
43 Davies Magdalene
44 George Charles, pilot
45 Rose Alf. Ernest
46 Card Oliver
47 Marney Mrs.
48 Davies Joshua, inspector
49 Davies J., rigger and contr.
50 Trepani Marano
51 Espeland & Jacobsen, ship chandlers

Southey Street, *Roath*
From Wordsworth Avenue
1 Copner John
2 Addie Gavin
3 Howells Thomas
4 Harris William
 here cross over
5 Fisher Mrs. Louisa
6 Telford John Alexander
7 Washer John
8 Williams M. A., com. travlr.
9 Davies John
——*Wordsworth St. intersects*
10 Burrows Henry, postal clerk
11 Brown George, postal clerk
12 Washer James
13 Thomas David, cooper
14 Donovan D., master mariner

Splott Road, *The Moors*
Pearl Street to Walker Road
1a Eveleigh George, bootmaker
1 Roath Carlylian Club & Institute Society, Ltd.—Isaac Watts, secretary
3 Freese George, confectioner
5 Boyes T. & Co., plumbers
Railway Bridge
11 Baker Geo. F., hairdresser
13 Heatley Janet, draper
15 John Mrs. Margaret, confcr.
17 Abrahamson J., pawnbroker
——*Railway Street intersects*
Splott Road Baptist Chapel
19 Garrett David, carpenter
 Garrett Miss A., confectioner and tobacconist
21 Thomas A. C., baker
23 Pratten Henry, bootmaker
25 Brittan H. J., general shop
27 Norman G. H. D., ironmongr and Sheffield warehouse
29 Splotland Drug Co.—W. H. Furnivall, proprietor
31 Luxton Cornelius, dairyman
33 Gilroy Timothy, shopkeeper
35 House James, bootmaker
37 Tompkins E. H., corn dealer
39 Pengelly Wm. T., hairdresser
41 Davies Thomas, draper
——*Carlisle Street intersects*
St. Saviour's Church
43 Dawson Rev. J. E. (St. Svrs.)
45 Ball John, master mariner
47 Clatworthy Joshua

49 Bowman William Henry
51 Bale Henry, police
53 Organ Henry, coal trimmer
55 Clarke Thomas, coal trimmer
57 Bowden Thomas, labourer
59 Collier Samuel, ship's steward
61 John Thomas
63 Davey Elan, coal trimmer
65 Bartlett Samuel, guard
67 Crabb Mrs.
69 Comley Jacob, builder
——*Habershon Street intersects*
71 Morgan John, bootmaker
73 Bird James
75 Clemerson George, engineer
77 Perkins Thomas G., engineer
79 Williams Philip, ship carpntr.
81 Winter George, coal trimmer
8 Haddon Isaac, boiler maker
85 Saunders P., mariner
87 Audridge Philip
89 Hazard Mrs. E.
91 Durkee James, engineer
93 Lewis Thomas, mason
95 Baker Miss, milliner
97 Williams Thomas, fitter
99 Jeffery William
101 Gough Charles, policeman
103 Thomas David, fitter
105 Morgan William
107 Davies John, clerk
109 Ross James, labourer
111 Lewis John, coal foreman
113 Wiles Rev. George (Weslyn)
 here cross over
Williams Wm., Splott farm
104 Birney Rev. Thomas (St. Saviour's)
102 Edwards Thomas
100 Hill William
98 Davies William, fitter
96 Merrett James, slate mason
94 Bush George, foreman
92 Rockhey Tho., coal trimmer
90 Williams David, boilermaker
88 Melhuish John C.
86 Roberts William
84 Hosington John
82 Winter William Thomas
80 Evans Thomas, fitter
78 Davies William, fitter
76 Davies David, smith
74 Mitchell Wm., shipwright
72 Horwood John K.
70 Harris John, shipwright
68 Brooks Thos. Wm., mate
66 Andrews J., mason
64 Knight Tom, guard
62 Noel George, engine driver
60 Mactavish Donald
——*Habershon Street intersects*
56 & 58 Wooldridge W., grocer and butcher
52 Galsworthy James
50 Clatworthy John Jesse
48 Bradley James, boatman
46 Pepper Edward Williams
44 Smith James
42 Rutherford James, mariner
40 Barnicott Edward
38 Dunrick Charles, coal trimmer
36 Wilkinson John, carpenter
34 Bradley Wm. Richard, formn.
30 Ridler Robert Thos., grocer
28 Griffiths Henry, tailor
26 Cridland James, greengrocer

24 Jenkins David
22 Logan William
 Logan The Misses, dressmkrs.
——*Carlisle Street intersects*
20 David Mrs. A., draper
18 Pleydell R. G., butcher
16 Harding George, greengrocer
14 Parker Geo. R., confectioner
12 Noel Matthew John, painter
10 Small Albert Rice, grocer
8 Fleming Mrs., stationer
6 Kirk Miss Hannah, confectnr.
4 Thomas Wm. Steephen, dprs.
2 Fargher Charles, chemist

Extract from Daniel Owen & Co.'s *Cardiff Directory* of 1895 showing Splott Road.

Nine
Trade, Industry and Transport

Another manifestation of change between 1850 and 1914 was the growth of industry. In 1840 Roath Mill represented the only outward sign of industry, albeit a traditional rural one, though there would have been other agricultural trades and crafts. By 1914 there had been a transformation. Railways, wagon works, chemical and gas establishments, copper, iron and steel works, timber yards and saw mills, a slaughterhouse and market, electrical works, tramway sheds, a pottery and brick works, a biscuit factory and a brewery bottling plant were among the enterprises that had been established. More developments occurred in the inter-war years, notably the Cardiff Municipal Airport, whilst the 1950s saw the establishment of industrial and trading estates in the vicinity of Newport Road and Colchester Avenue – an area which has witnessed a more recent transformation with the development of edge-of-town superstores and other retail units.

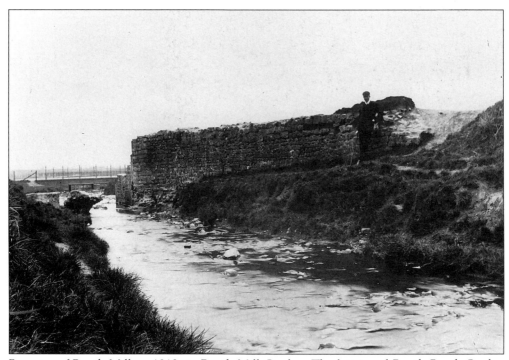

Remains of Roath Mill, c. 1912, in Roath Mill Garden. The latter and Roath Brook Garden were collectively known as the Roath Brook Gardens and more usually as the Pen-y-lan Brook Gardens. They covered an area of some $5\frac{1}{2}$ acres.

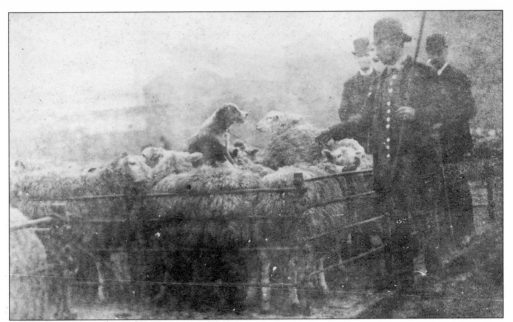

Roath Market, 1891. The cattle market and slaughterhouse was opened on 11 March 1862. It was bounded by Constellation Street, Cycle Street, Platinum Street and the South Wales Railway. In 1891 David John was market manager and he lived at 58 Cycle Street with his wife and six children. In 1881 Hartley Nicholls was described as "Inspector of Cattle and Slaughterhouse". The market closed c. 1971. The houses of Anderson Place now cover the site.

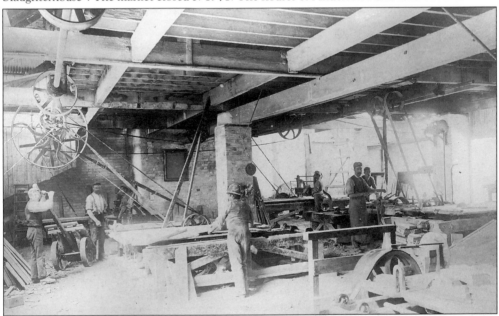

Corfield & Morgan's steam slate, marble and moulding manufactory, 74 Metal Street, October 1893. Established in the mid to late 1870s, it manufactured enamelled slate chimney pieces, lavatories, slate floors and hearths, baths etc., and undertook all kinds of monumental and roofing work. Its offices were at The Parade. By 1899 a haulage business had taken over the Metal Street premises.

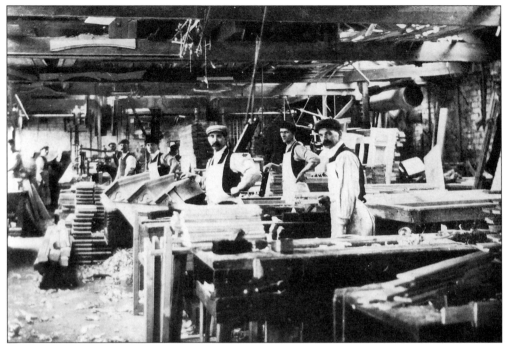

Harry Gibbon & Sons, timber and builders' merchants, Crwys Steam Joinery Works, 185 Richmond Road (Richmond Lane), c. 1909. Established in the 1860s, it manufactured "every description of joinery", its specialities being church seating, school benches, school-room partitions in oak and pitch pine. The business still trades as a builders' merchants.

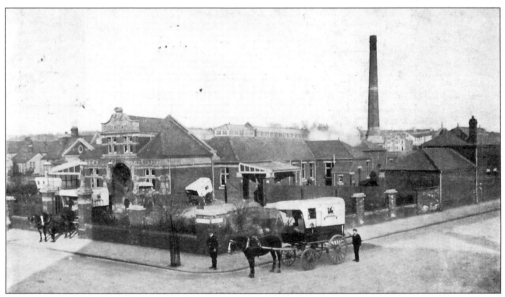

Roath Steam Laundry, 1909. This business was established in 1899 on the corner of Blenheim Road and Marlborough Road. The premises were later occupied by United Welsh Mills (from c. 1923), and in more recent times by Marlborough Carpets and currently Bedy Buys Ltd.

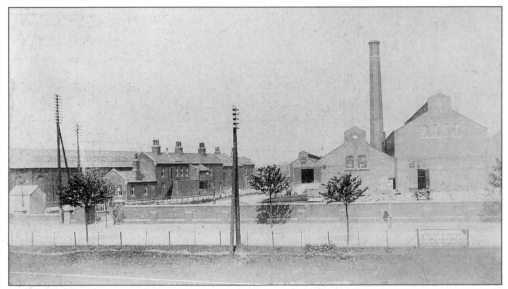

Roath Electric Power Station, 1907. It was situated on Newport Road in an area now partly covered by Allied Carpets and Sainsbury's. Built in 1901, it commenced supplying tramways the following year. The Roath tram depot, erected in 1902, stands next to the power station.

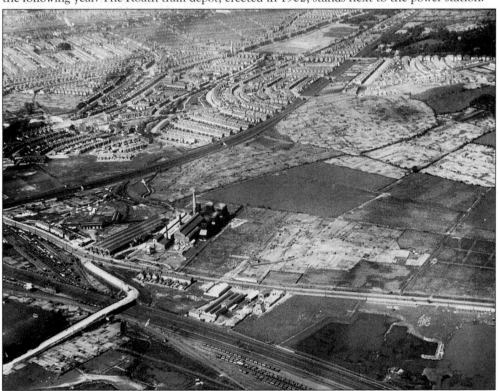

Roath Power Station, 1927, showing in the background the built-up area of Penylan. To the right of the power station is where the Roath Pottery and Brick Works (c. 1900 - c. 1917) stood. Most of the open land north of the Newport Road formed part of the William Mark Wood estate in the mid-nineteenth century (Griffithsmoor in the medieval period).

The Metal Alloy Works with Roath Power Station in the background, *c.* 1948. Colchester Avenue (opened 1912) runs 'vertically' to the left. The works was described as "quite modern" in 1920 and expansion took place in the 1930s. The pre-war cooling towers were demolished in May 1972. Originally there were three towers constructed of wood (!) and mounted directly over a tank or tray.

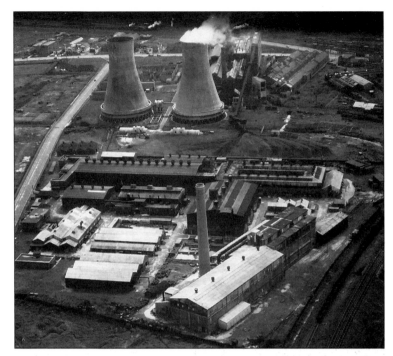

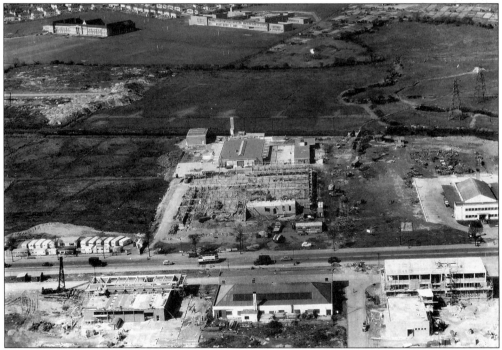

New businesses on Newport Road, 4 April 1957. Farmers & Dairymen is on the extreme right, the north side of Newport Road. The building under construction is Howell's Garage. The Lady Margaret High School for Girls (opened in 1948) is top left, while top centre is the Howardian High School for Boys (opened in 1953). The schools merged in 1970 and closed in July 1990. Private housing now occupies the lower site.

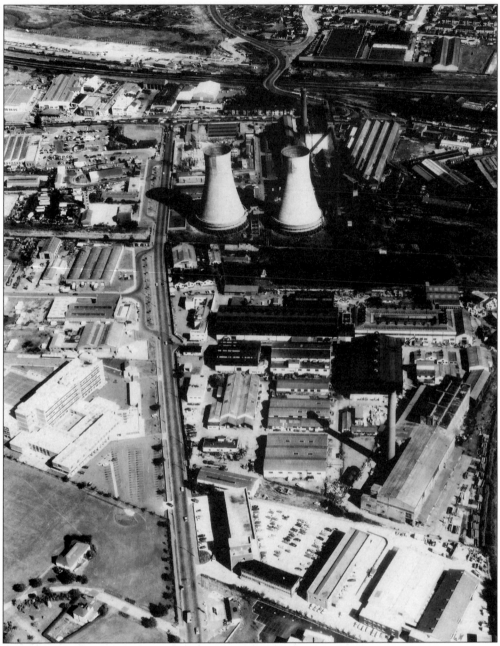

Part of the Colchester Avenue Trading Estate (developed from 1955), *c.* 1969, with the Roath Power Station prominent in the background and the Metal Alloy Works in the foreground.

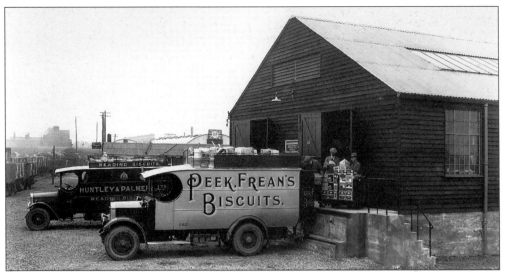

The Associated Biscuit Company's warehouse at Newport Road sidings, 1932. It is now a small trading estate comprising T.G.I. Friday's, Habitat, Children's World and other units.

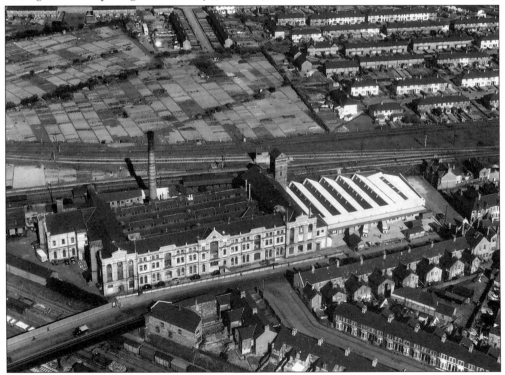

C.W.S. Biscuit Factory, Moorland Road, c. 1956. The extensive biscuit works of Messrs Spillers Nephews Ltd, was erected in 1895 on a three acre site. At the time it was equipped with the most modern machinery and gave employment to some 250 people. It became the C.W.S. Biscuit Factory c. 1921, and in the 1960s was converted into a Leo's Supermarket (closed c. 1986). Damaged by fire, it was subsequently demolished, and is today the site of a private housing estate. In the background (right) are Skelmuir, Craigmuir and Dalmuir Roads which were developed from 1927. The open space is now taken up by housing and trading estates.

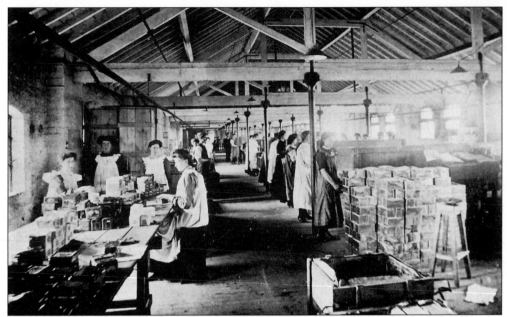

The export packing room inside Spillers Nephews Biscuit Factory, 1908. About 5,000 boxes of biscuits and four tons of "albatross" self-raising flour were packed and despatched daily.

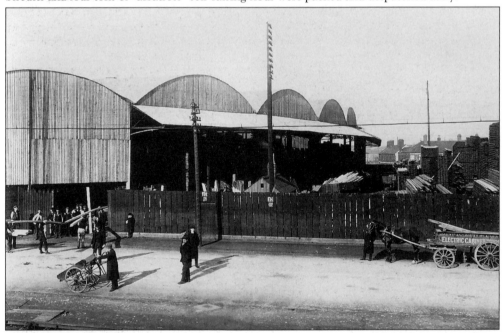

Robinson, David & Co.'s timber yards and saw mills as seen from East Tyndall Street, *c.* 1900. The site, sandwiched between Sanquahar Street and East Tyndall Street and now partly taken up by Splott Market, was occupied in 1900 by two timber merchants, John Bland & Co. Ltd. and Robinson, David & Co. Ltd. The Cardiff, South Wales and Monmouthshire Hide Skin, Fat and Wool Co. Ltd, were also there. John Bland and Robinson David, together with Meggitt & Jones Ltd still occupied the site in the 1970s. Bland was established there by at least 1886, during a period which saw a great expansion in the local timber industry.

136

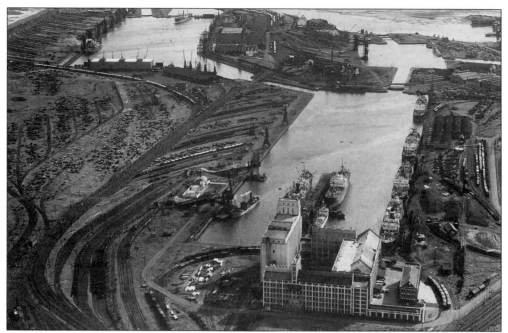

Roath Dock, Roath Basin and Queen Alexandra Dock, August 1953. Roath Dock (foreground) was the only one to fall partly within the confines of the old parish. It opened in 1887 and was 33 acres in area. At its head are the Spillers flour mills, erected in 1936. The firm of Joel Spiller & Browne was established at the West Bute Dock in 1854. In 1880 the firm became Spillers & Co., and in 1890 Spillers and Bakers Ltd. Today it is Spillers Milling Ltd.

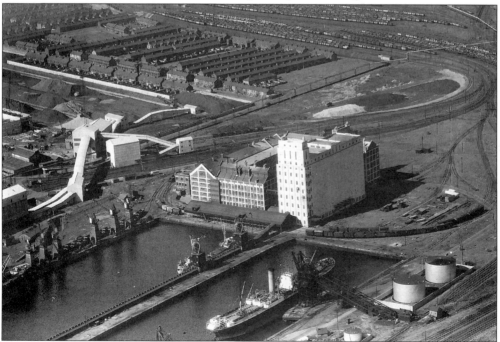

Another superb view of the Spillers flour mill, May 1957, showing in the background the now demolished streets of lower Splott (from Menelaus Street to Smith Street).

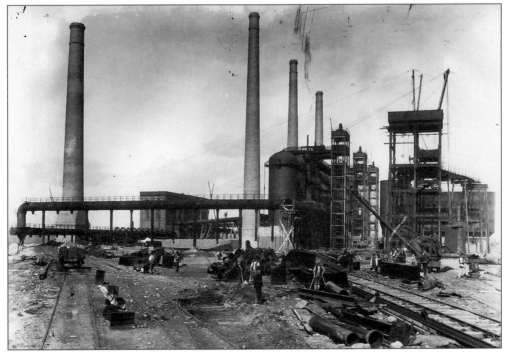

East Moors blast furnaces, 1890. Historically the East Moors formed part of the Adamsdown estate of the Butes. The Dowlais Iron Company commenced production in 1891, the steelworks starting in 1895. In 1901 the company was taken over by Guest, Keen & Company, which in 1902 became G.K.N. The plant was redeveloped from 1934. Production ceased on 28 April 1978, and the works was subsequently demolished in 1979.

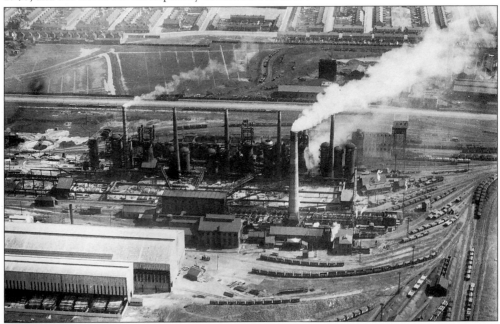

G.K.N. Steelworks, 1927, showing in the top right the Tharsis Sulphur and Copper Works and, top, the streets of lower Splott; from left to right: Wimborne Street to Layard Street.

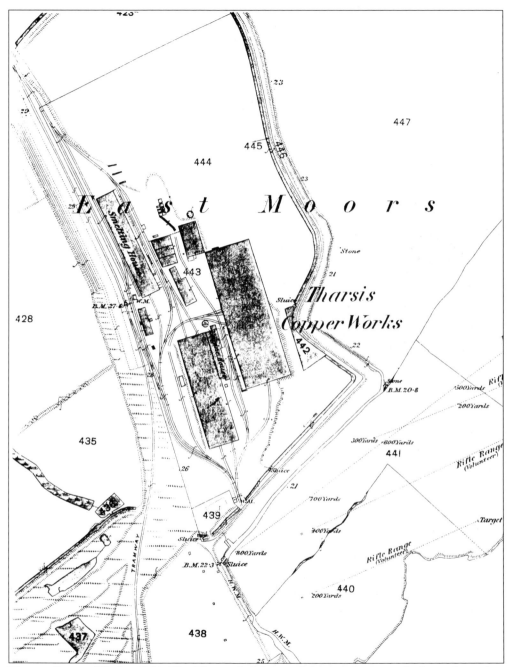

Tharsis Copper Works, 1881. The Tharsis Sulphur and Copper Company Ltd, was formed in 1866 and had six metal extracting works in Great Britain, including the one in Cardiff started in 1873 on Adamsdown farmland. This closed c. 1919, but reopened in the 1920s, only to close again c. 1927. The works was still registered at East Moors in 1937, but by 1942 the site had been completely cleared.

Three views of Cardiff Municipal Airport, Pengam, December 1953, showing Cambrian Air Services planes. The site covered 176 acres. It commenced operations in 1930 on Pengam Moors, and within twenty years had achieved the third highest aircraft movement rate in Britain. A considerable fillip to its prestige was when the Prince of Wales arrived for official visits to the city in May and June 1930, and a few years later he agreed to become patron of the Cardiff Aeroplane Club. In 1933 the Great Western Railway were offering domestic flights to Torquay and Plymouth at a single fare of £3 and £3. 10s. By 1938 there was a regular hourly

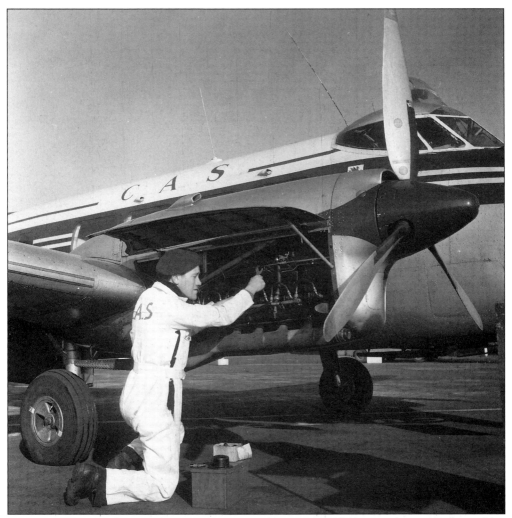

service to Weston, the ten minute return journey costing 9s.6d. During the war Pengam, like most municipal airports, was requisitioned by the R.A.F. to become the first war station for 614 Squadron. In February 1940 No. 43 Maintenance Unit was opened to act as a packing depot for aircraft being shipped overseas, and rapid changes were made. The allotments at the airport entrance were levelled to permit exit of dismantled airframes, a site was prepared for packing cases and the hangars were refurbished. Aircraft which arrived for packing included Tiger Moths, Harts, Lysanders, Hurricanes, Gladiators and Hinds. By May 1941 the airport was known as R.A.F. Cardiff. The preparations for D-Day involved the storage of vast quantities of aviation fuel in jerry-cans on the airfield. The number of aircraft being packed (mainly Seafires) slowly dwindled through 1945, and the M.U. closed on 31 October 1945. Its last few Spitfires were despatched the same day, bringing to an end an unspectacular but invaluable contribution to the war effort. After 1945 the airport was used by the Ansons and Tiger Moths of 3 Reserve Flying School, British European Airways, Cambrian Air Services and Western Airways. Unfortunately, the short runway, cramped position and lack of night flying facilities proved its downfall. On 1 April 1954 all civil flying was transferred to Rhoose, and the airport later became an industrial site after a period housing the Ministry of Transport and Civil Aviation's fire-fighting school before it moved to Stansted in 1960. Several of the airport's former hangars, however, are still in use as workshops and factories in Seawall Road.

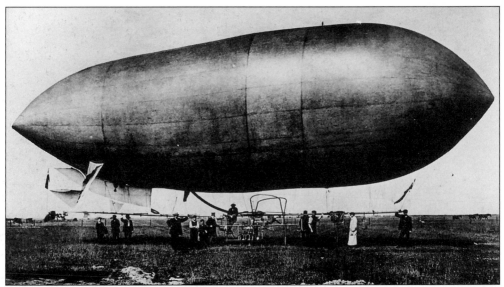

The Welsh dirigible Willows II, August 1910. Ernest Thompson Willows was a pioneer aeronaut and motorist. His dirigible, Willows II, which flew from Cardiff to the Crystal Palace, London in August 1910, was a big talking point. He was killed in a balloon disaster near Bedford in August 1926, aged 40. Willows High School is named after him.

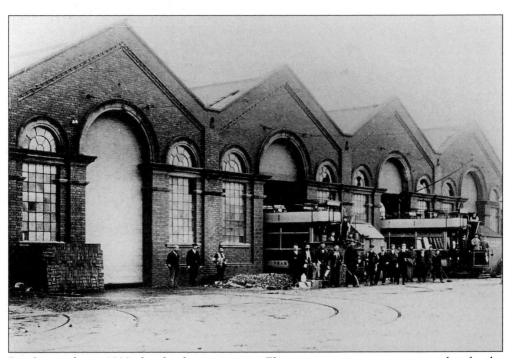

Roath tram depot, 1902, shortly after its opening. Electric tramways were constructed under the Cardiff Corporation Act of 1899. The system was partially opened for traffic on 1 May 1902, the route milage then being 17 miles and the total track length 32 miles. The total number of tramcars that year was 130. The depot, or car shed, above included repair shops for the maintenance of the rolling stock.

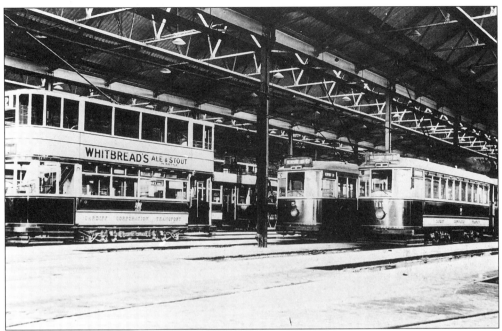

The interior of Roath tram depot, 1936. On the right of the standard Cardiff Corporation double-deck car is a batch of 44-seater bogie cars which were delivered new in 1926-27.

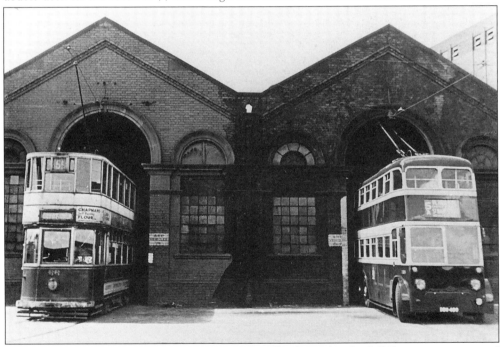

Roath tram depot, 1948, showing a tram and a trolley bus. The Cardiff Corporation operated motor buses from 1920, and gradually they superseded the trams. No further tramways were constructed after 1929 though the service did not come to an end until February 1950. In 1942 trolley buses appeared in the streets and remained until they too were discarded in 1970. The tram depot was demolished mid-1987.

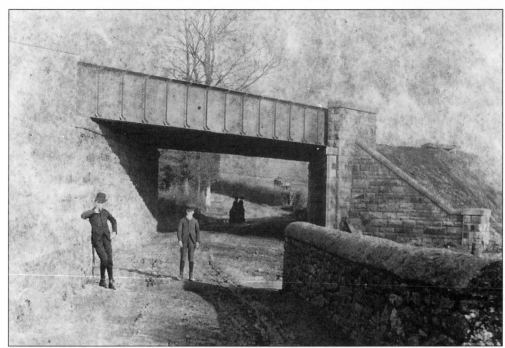

Fairoak Road Bridge, *c.* 1900, showing in the distance the fields of Fairoak Farm. The bridge carried the Roath branch line of the Taff Vale Railway. This was opened in 1888 by the T.V.R. Company as a freight line. It was about five miles long sweeping in a 'J' shaped curve from Llandaff to the Roath Dock via Roath. It closed on 4 May 1968.

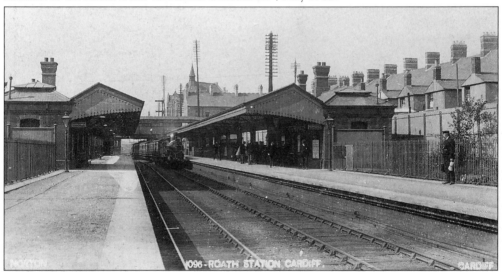

Roath Railway Station, *c.* 1910. This was opened in 1899 off Pearl Street. During the First World War the station was used as a reception centre for wounded troops who were taken to the nearby Splotlands Board School, then in use as a military hospital. The station closed on 2 April 1917. The badly vandalised station building was leased by the Splott & District Amateur Operatic Society in 1963 as a workshop for making scenery and props. The entrance building fronting the street has since been replaced by an extension to the Roath Carlylian Club and Institute, now Old Illtydians R.F.C.

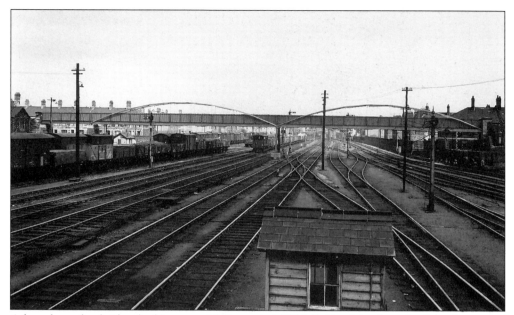

Adamsdown footbridge, looking east, 13 December 1954. Said to have been built at the time of the South Wales Railway (1850), it is shown on Waring's map of 1869 (see page 13). Colloquially known as the 'Black Bridge', it connects Kames Place and Adamsdown Square (shown left) with Adamsdown Place (shown right) and Sanquahar Street.

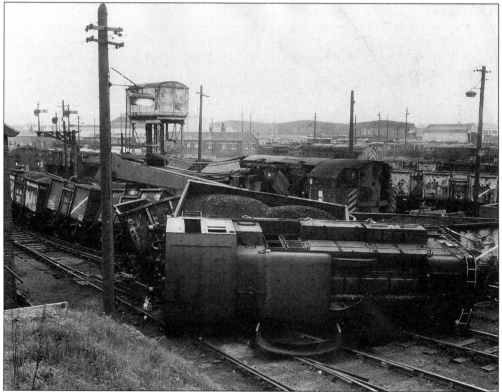

Derailment at Swansea Street lower level sidings, Splott, *c*. 1963.

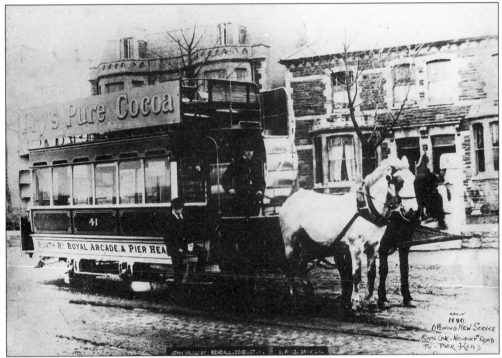

Newport Road, c. 1890, and the opening of a new horse-drawn tram service between the Royal Oak and Pierhead. The trams carried 24 on top and 16 inside. The driver is G. Pyke and the conductor John W. Bendall. As early as 1855 horse buses were running every half-hour from the Queen's Hotel (Queen Street) to the railway station and the dock, marking a new stage in the growth of public transport. The Cardiff Tramway Company's horse-drawn tramline from High Street to the docks was opened on 15 July 1872.

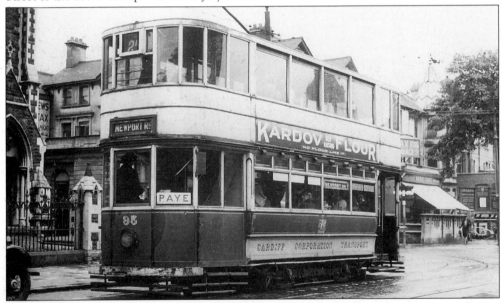

A Cardiff Corporation Transport tram running along Newport Road, at the junction with City Road, c. 1935.

Ten

Leisure and Recreation

Cardiff has been called a 'city of parks' and several of the more significant ones as well as public gardens fall within the confines of the old parish. In terms of sporting endeavours the district has a rich heritage particularly in athletics, baseball, bowls, boxing and football. In respect of cultural activities the Splott and District Amateur Operatic Society and the St Alban's Brass Band spring readily to mind whilst the facilities for reading, cinema-going, adult and community education, amongst other pursuits, have also been important in the past.

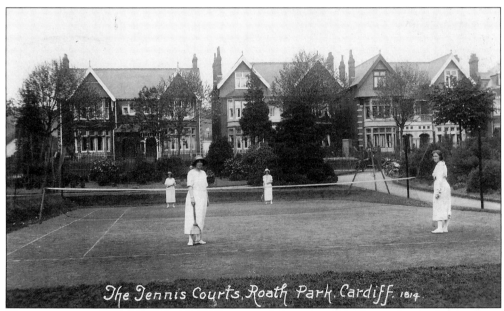

The tennis courts, Roath Park, 1927. The site of these courts has since been taken up by a bowling green. Ty Draw Road in the background was developed from 1903 and lay on Bute estate land. The first house plans date from 1904.

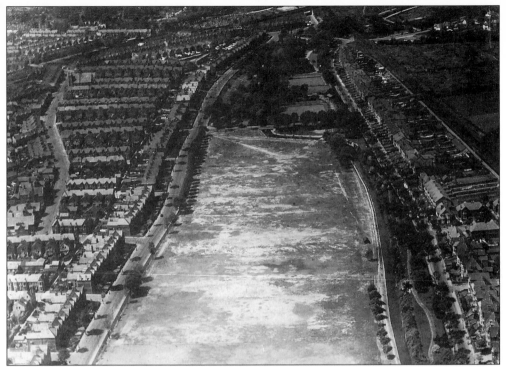

Roath Park recreation ground, June 1930. The land from which this part of Roath Park was developed (Penywain Farm) was presented to the town by the third Marquess of Bute in 1887. Certain small pieces of land were also given by other landowners, including Lord Tredegar. The park cost nearly £62,000 and opened on 20 June 1894. This portion has always been devoted to games, particularly football and baseball. Including the lake and botanic gardens the park covers an area of 133 acres.

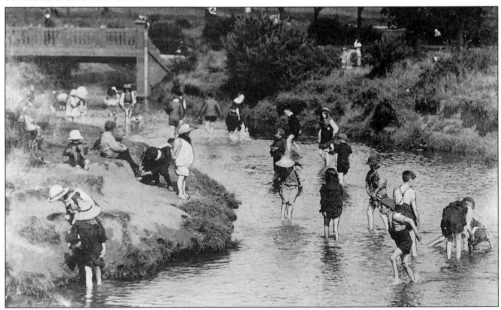

Paddling in Roath Brook, Roath Park recreation ground, c. 1910.

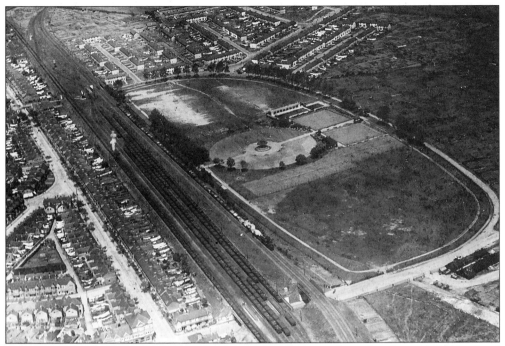

Splott Park, June 1930. Covering 18 acres, it was presented to the Corporation by Lord Tredegar in December 1901, and was mainly carved from Splott farmland. Running parallel to the Roath branch line of the T.V.R. is Moorland Road, at the bottom of which (left) is the recently refurbished Grosvenor Hotel. Built in 1893, its size is testimony to the thriving commercial nature of the area at that time.

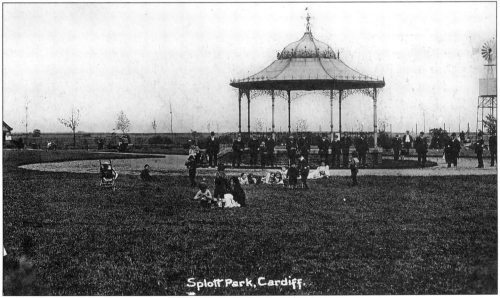

Bandstand, Splott Park, c. 1910. It was erected in 1905 and was 'home' to the Splott Temperance Band. Cricket pitches were laid in 1904 and practice pitches (with nets) the following year. A children's playground was set aside in 1904 and a quoits pitch was prepared in 1907.

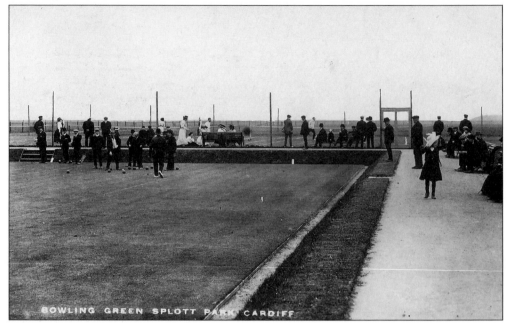

Bowling green, Splott Park, 1912. The green was opened on 15 June 1906. The tennis courts in the background were prepared in 1907. Note the tide fields and the openness of the Splott Moors, which in past times was frequently inundated by the sea.

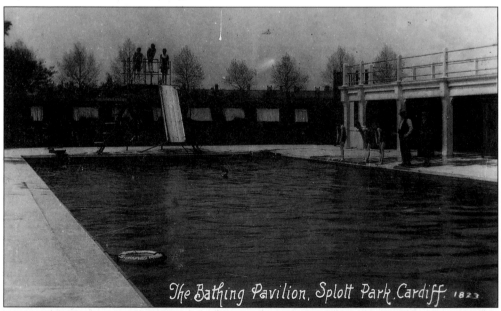

The bathing pavilion, Splott Park, c. 1925. The open-air baths were opened on 14 August 1922. The work of excavating the site had begun on 17 October 1921 and the concrete work was completed on 20 March 1922. New covered baths were opened in April 1976.

Playing on the moors, 1890. The *St Peter's Chair* had this to say of the area in June 1891: "ten years ago the flat land just outside the town of Cardiff, known as the East Moors, was, with the exception of a few cultivated fields attached to the farms of Pengam and the Splot, a sloppy waste stretching its dreary length to the shores of the Severn estuary, the monotony of the same being broken only by ditches and gates. But at Cardiff great changes occur in the course of ten years, and the past decade has seen this low-lying wilderness fall a prey to the building contractors, who have mapped it out into streets and covered it with a bewildering maze of houses, shops, taverns, and Board Schools". These two photographs reinforce this description. *Below*: children playing in view of the new Moorland Road Board Schools. The row in the foreground is thought to be Milford Street.

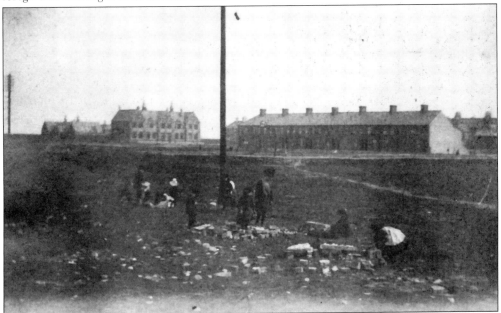

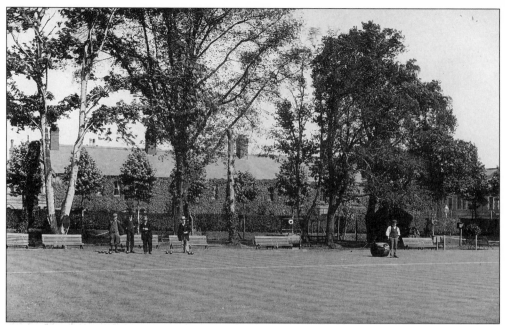

The Mackintosh Institute's bowling green, 1906. The houses in Plasnewydd Place are no longer covered by creeper.

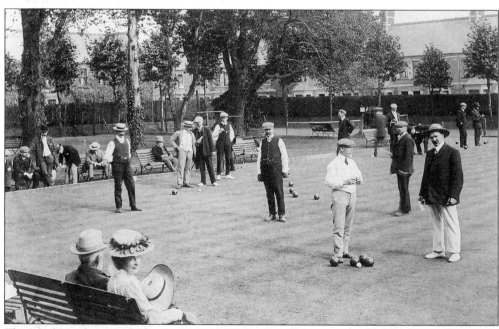

The Mackintosh Institute Bowls Club, 1912. Bowls and tennis are still played enthusiastically at the club. When donating the site in 1890 the Mackintosh of Mackintosh insisted that a library, reading room, billiard room, gymnasium, tennis courts and other leisure amenities be provided. In August 1986 it was agreed that the freehold for the two acre site be bought by the Mackintosh Sports and Social Club for £170,000.

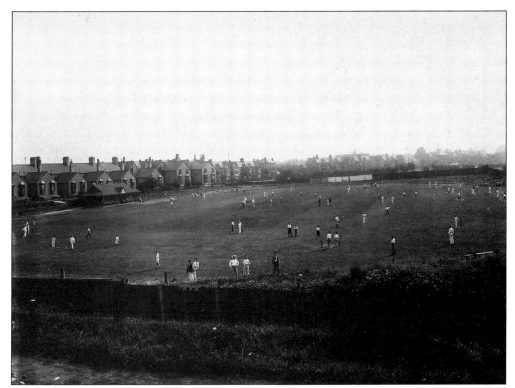

Harlequins recreation ground, Newport Road, as seen from the Taff Vale Railway embankment, *c.* 1899. Cardiff Harlequins Athletic Club ceased to exist in 1899 but the ground retained the name. The land covered by the recreation ground had been part of the Ty Mawr estate owned by Lord Tredegar.

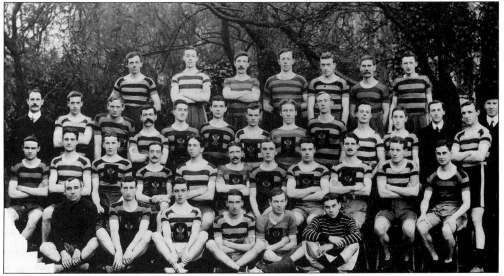

Roath Harriers, 1909-10. Formed in 1882, it was at one time Wales's oldest athletics club. The Royal Oak Hotel, Newport Road, was its first headquarters and over the years the club won many championships. In 1968 it merged with Birchgrove Harriers to form the Cardiff Amateur Athletic Club.

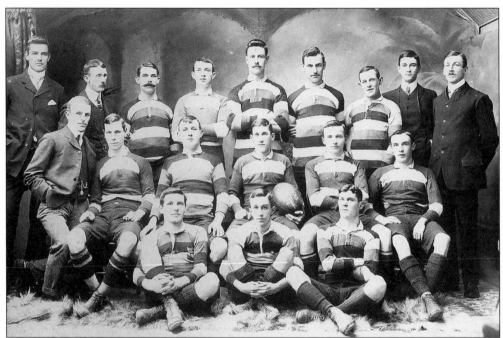

Penylan Football Club, 1902-3 season. Founded in 1891, the club played all its matches away. Among those they faced were Pontypool, Abertillery and Tredegar. Its headquarters were the Ship on Launch, Quay Street, and its colours were red, black and white. The President was Dan Radcliffe, shipowner, of Tal-y-Werydd, Penylan, and among the vice-presidents was W.J. Tatem (Lord Glanely), another shipowner, who lived at Shandon.

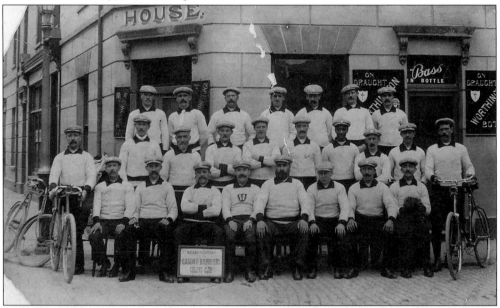

Cardiff Ramblers Cycling Club, outside the Clifton Hotel, c. 1910. The latter was built in the 1850s and, like the Great Eastern Hotel, probably took its name from another of Brunel's achievements, the Clifton Suspension Bridge, which although designed in the late 1820s was not finally completed until 1864.

'Lovers Walk', Plasnewydd, 1882. This is shown as plots 166 and 163 on page 40. From reminiscences published in 1936 it was stated that "in 1886 Kincraig Street was a drive leading to Plasnewydd mansion. On the corner of the drive was a keeper's lodge with a copse of trees. From the lodge a wall ran part of the way up what is now City Road. At the end of the copse of trees the 'lovers walk' started and proceeded right across the green park to where Claude Place stands today". Cartographic evidence is strongly suggestive that Glenroy Street, constructed 1885-6, follows the course of the 'Lovers Walk'.

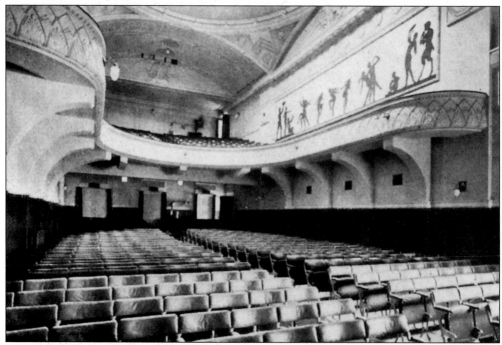

Above: the Penylan Cinema, *c.* 1923, and, *below*, as The Globe shortly after its closure in 1985. The Penylan Cinema opened on 27 August 1914. The panel advertisement in the *South Wales Echo* that day read: "Penylan Cinema, Albany Road. Open to-day at 7 p.m. The whole proceedings of the first three days will be given to the Prince of Wales Fund. This cinema is absolutely without exception original, hygienic and up-to-date. Prices of admission. Balcony ls. Stalls 6d. Pit stalls 3d. Every Patriot should patronise this British owned and controlled Cinema". Renamed The Globe in the 1940s it was latterly well patronised by students. It closed on 25 May 1985 and was demolished in April 1986. It is sadly missed.

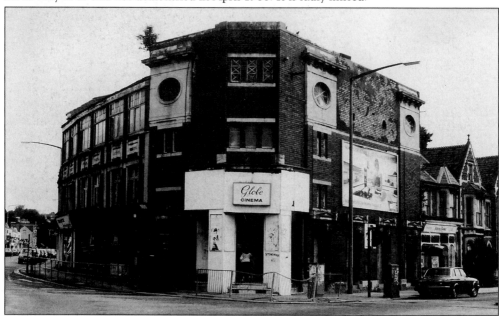

PENYLAN CINEMA

(The Cinema de Luxe)

Corner of Albany and Wellfield Roads.

RESIDENT MANAGER - EDW. J. MORRIS.

THIS up-to-date Picture Theatre is beautifully decorated in artistic style, and no expense has been spared to ensure the comfort :: :: :: of Patrons. :: ::

The Programme is carefully selected by Experts, and the Latest Films are secured immediately they become available in the Provinces (see Press Advertisements for Details).

AN EXCEEDINGLY POPULAR
FEATURE IS THE MUSICAL
INTERLUDE, RENDERED BY
AN AUGMENTED ORCHESTRA
UNDER THE DIRECTION OF
- - Mr. W. DONOVAN. - -

Continuous Performances—2 till 10-30 p.m. daily.

The latest appliances (including a Sliding Roof) have been installed to ensure perfect ventilation, and the Theatre is delightfully cool in the hottest weather. :: :: ::

A 1921 advertisement. Over the years the cinema showed a mixture of the latest silent and talking melodramas, romances, as well as neo-realist continental films.

157

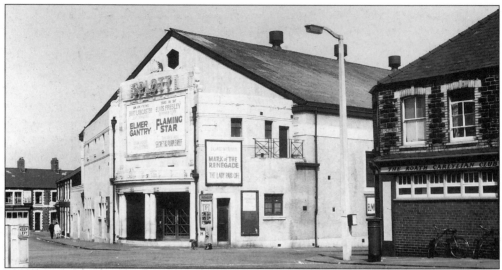

Splott Cinema, 1961, the year it closed to become a bingo hall. Built in 1913, it was one of two in the immediate vicinity, the other being the Clifton Picture House, Clifton Street, which was built in 1911 and converted by F.W. Woolworth & Co., the present occupiers, in the mid-1930s. On the right is the Roath Carlylian Club and Institute established c. 1896. Its motto was 'Friendship, Love and Truth' and its members were expected to adopt the principles of Thomas Carlyle whose life had been devoted to improving the society of the day. It closed in April 1985. The Old Illtydians R.F.C. acquired the premises later that year and named it Carlyle House.

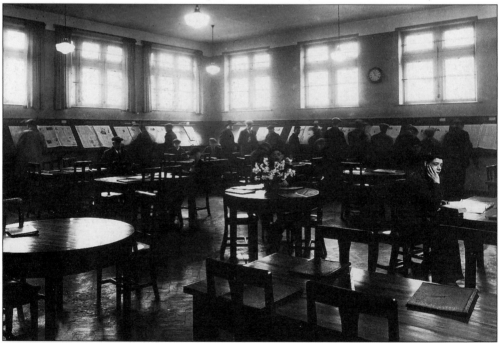

Splotlands Branch Library reading room, Cardiff's first purpose built branch library. First established in 1894, it reopened as a lending library on 28 May 1900. In February 1931 it was again reopened after a children's hall and reading room were incorporated. The library was built on land in Moorland Gardens (1½ acres) donated by Lord Tredegar on 16 September 1890.

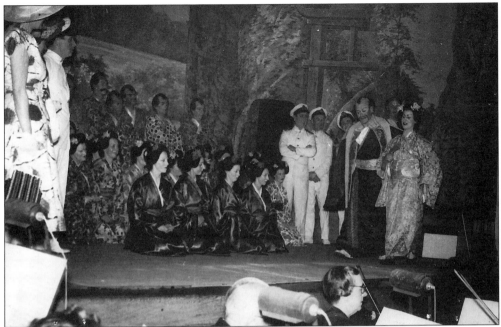

The Splott and District Amateur Operatic Society was formed in March 1954. Its first show *The Geisha, above*, was produced in May 1955 at the old St Illtyd's Hall on Courtenay Road. The society played there until 1966 when the building was sold. Rehearsals were held in Splott Road, Willows High and Baden Powell schools and Splott Road Baptist church hall. Since 1991 it has rehearsed and performed at the East Moors Community Education Centre, Sanquahar Street. 1995 saw the Society's fortieth anniversary with the revival of *The Geisha*. Below: rehearsals for *The Rebel Maid*, Splott Road School, 1957.

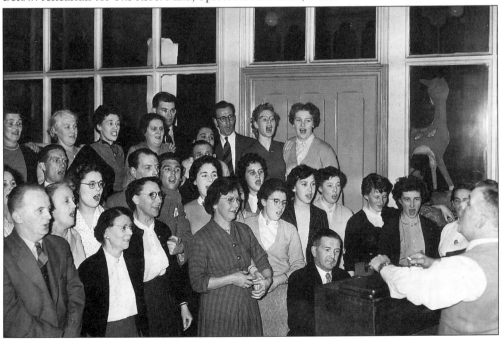

Acknowledgements

I would like to thank the following individuals and organisations for their help in the compilation of this book.Mrs Susan Williams M.B.E., J.P., former Lord Lieutenant of South Glamorgan, for writing the foreword, for the loan of the photograph on p.43 and for her kindness generally. Simon Eckley of the Chalford Publishing Company for inviting us to contribute to the Archive Photographs series and for his helpful and constructive advice throughout. The book would not have been possible, however, without the co-operation, generosity and help afforded by South Glamorgan County Library (and particularly Mr Bryn Jones of the Local Studies Department) and Mr Colin Jones, son of the late Fred Jones whose collection of Cardiff postcards is without equal. Both the Fred Jones Collection and that of South Glamorgan County Library provide almost two-thirds of the items contained in this work.

I am also grateful to the following organisations for allowing us to reproduce photographs and other images: Aerofilms of Borehamwood (pp.14-17); Glamorgan Record Office (pp. 6, 13, 20(A), 28(A), 29(A), 30, 153(B)); National Library of Wales (p.35); Ordnance Survey (pp. 40, 139); Royal Commission on the Ancient and Historical Monuments of Wales (pp. 8, 44); Welsh Folk Museum (pp. 2, 19, 22(A), 23, 25(A), 29, 36(A), 48(A), 58(A), 64(A), 66(B), 70(A), 98, 107(B), 125(A), 129, 142(A)); Welsh Industrial and Maritime Museum (pp. 18(A)*, 18(B), 38, 75, 133*, 134*, 135(A), 135(B)*, 136, 137(A), 137(B)*, 140*, 141*, 142(B), 143, 144(A), 145(A), 146(A) – * by permission of H. Tempest Ltd (donor)); Western Mail and Echo Ltd (pp. 12, 39(B), 115, 159(B)).

Donations or help from the following individuals were also much appreciated: Joan Allen; Peter Bennett; Joy Bowen; Peter Bowen; Joan Childs; I. Davies; Arthur Weston Evans; Don Farr; Lyn Forse (Roath Court Funeral Home); the head teachers of Albany Primary, Marlborough Junior and St Anne's Church in Wales Primary Schools; Jeanette Heron; Hazel Hicks; Frances Hobbs; Rose Horner and Pat Joyce (Oldwell Court Day Centre); William Howells; Judith Hunt; Brian Ll. James; Alan Jarvis; Dr David Jenkins; T.G. Jennings; Beryl Jones; Dorothy Jones; Lorraine Lammas (and other pupils of Willows High School); Mary Llewelyn; Alun Mayer; Sian Morgan; Con O'Sullivan (the Lower Splott Oral History Project); Cecilia Owen; Bill Penney; Mary Peters; Iorwerth Rees; P.C.F. Roberts; Chris Shylon; Gwyn Smith; Gwilym Tawy; Beryl Thomas; Maud Thomas; Carol Tilley; Josephine Tyler; and John West.

Special thanks to the Society's project team who worked so assiduously to help put the compilation together: Peter Gillard; Nancy Keir; Margaret Reeves; Martin Sheldon and Vic Smith.

Finally tribute must be paid to the late Alec Keir, the founder of the Roath Local History Society, without whose inspiration and research this work would have been a lot poorer.